JONATHAN BENTHALL

SCIENCE
AND TECHNOLOGY
IN ART TODAY

PRAEGER PUBLISHERS
New York · Washington

BOOKS THAT MATTER
Published in the United States of America in 1972
by Praeger Publishers, Inc.
111 Fourth Avenue, New York, N.Y. 10003

© 1972 in London, England, by Jonathan Benthall

Library of Congress Catalog Card Number: 78–183061

Printed in Great Britain

CONTENTS

To Stefano Michaelis

Preface

The subject of this book is complex. I have tried to avoid unsupported generalizations, inessential technical detail, and personal polemic. I have treated very lightly the historical background to the present 'art and technology' or 'science in art' movement — for instance, the Bauhaus, the early Soviet avant-garde, etc.; partly because this background has been amply documented by other authors (to whose works references are given), and partly because I feel the most urgent need is for a fresh approach.

Chapters One to Four are largely concerned with the relationship between art and media, focusing on three media: photography, the computer, and laser holography. In Chapter Five, which is primarily a study of kinetic art and some of its repercussions, the emphasis shifts from media to expression. Chapters Six and Seven are devoted to some implications of ecology and linguistics, respectively, for art and culture. Chapter Eight reviews some aspects of the relationship between science and art, arguing that this relationship can best be understood if art is regarded primarily as a mode of enquiry.

I considered adding a final chapter on 'Social Responsibility in Science and in Art', but decided that if my conception of social responsibility means anything it would be implicit in the texture of the whole book. I take as a starting-point the fact that many people in both science and art are trying to relate their work more tellingly to the problems of society as a whole. I sympathize with those who resort to political activism; but for me there are underlying issues of creativity and community which claim first attention.

A bibliography, in alphabetical order by author's name, is included at the end of the book. Those marked with an asterisk (*) are specially recommended for further reading. Works in the bibliography are referred to in the text by the author's name, followed sometimes by year of publication and the letters *a, b, c,* etc. where the same author has published more than once in a given year. The reference *Page* (followed by a number) refers to numbers of the regular bulletin *Page* produced by the Computer Arts Society.

ACKNOWLEDGMENTS

Much of the argument of this book I have tried out earlier in a variety of journals and exhibition catalogues, and especially in the pages of *Studio International*. I am grateful to this journal, and to the Institute of Contemporary Arts, London, for their willingness to ignore conventional boundaries.

Debts to individual artists and writers will be evident from the text.

Art and Technology

Great hopes have been expressed about the reuniting of art with science and technology. It has been convincingly argued that there is a need for a more comprehensive approach to human experience, as a corrective to specialization and fragmentation. But this is an area of creative activity which has proved to be difficult both theoretically and practically.

There is a wide range of activity in this area (which is hard to define precisely) in many countries of the world, and a great deal of documentation. But the present situation of galleries and organizations concerned with such work, and the recent history of exhibitions, is far from encouraging. Two landmarks at the end of 1970 were the closure of the Howard Wise Gallery in New York, for eleven years a pioneer in the development of new forms of kinetic and 'technological' art, and an ambitious exhibition called 'Software' at the Jewish Museum in New York, which was a technical disaster. Many artists have retreated from the difficulties of operating in the no-man's-land where art overlaps with science and technology.

It would be a mistake for artists and others to be daunted by these difficulties and apparent failures, since the potential is so very promising. Science and technology are central to most of the big issues in the world today. The largest set of issues is that of man's destroying, fouling or devastating his own natural and social environment. Here there is a wide range of dangers, from short-term to long-term, from local to global.

I believe that art has an important contribution to make here. But the time has come in the 'art and technology' or 'science in art'

movement for some hard thinking. In this book I try to stimulate such thinking, and for this reason there is a heavy emphasis on theory. As a personal assessment of the situation, it is neither exhaustive nor unbiased; but I have tried to give extensive references so that the reader can follow up any line of enquiry that interests him.

I had better explain how I will use the word 'artist' in this book. A case is often made for jettisoning the word and using some less emotive word like 'designer'. But no such alternative, I think, will do. (The term 'art worker' is a good one, but I shall not use it here as it is not yet common outside certain radical art circles.)

'Art' and 'artist' combine two associations. First, the idea of a technical skill or mastery of a medium – the older association. Second, the heroic resonances which are traceable to the Romantic movement and back to the Renaissance, and which I don't think we can do without: the notion of the artist as someone who takes an uncommon responsibility for what he does, and whose work is judged against a formidable tradition of moral and imaginative grandeur.

But the title of 'artist' should not be confined to people who produce what society recognizes as 'artefacts', or to people who benefit from the high prestige that 'being an artist' can accord. There is a general tendency today to locate art more in the inter-change of organized consciousness than in the transubstantiation of materials by genius into artefacts and masterpieces.

The term 'artist' is irreplaceable, whatever strains and paradoxes it leads us into, because it combines the sense of 'visionary/philosopher/prophet' with the sense of 'craftsman/technician/designer'. A visionary or philosopher is not called an artist, nor should he be, unless he can transmit his perceptions in terms of a *technical medium*. (This may, of course, be the written or spoken word; but it is possible to be a convincing philosopher or an inspired prophet while speaking or writing incompetently and insensitively, and such people are not thought of as artists, though they may influence society as much as any artist.) A craftsman is not called an artist unless his medium is informed by some unusual

12

clairvoyance or imagination. An artist, like other workers, has to organize his resources and find economical solutions to problems; but the kind of organization that distinguishes him is a matter of coordinating technical resources with psychological or spiritual resources, so that there is a continuous process from idea to technical expression and back to idea. Given this definition, it is self-evident that there is an artist (in a weak sense of the word) in every man, since no one would be able to get through life without a measure of this organizing or coordinating power.

Society as a whole is beginning to subject its entire technological apparatus to ecological scrutiny, and also the alleged objectivity and neutrality of science to socio-political scrutiny.[1] The authority and prestige of science and technology are in jeopardy, but their centrality to our world is more evident than ever. The challenges open to the artist to confront and interpret the world, and thereby help to change it, are greater than ever.

In the later part of this book, I shall consider the relationship between science and art from a theoretical point of view. In the first few chapters, however, my primary concern is with new technologies and media, and with artists who are using them. I do not mean to belittle other artists who prefer to use old-established media, or who are indifferent to science and technology. It is a great mistake for any commentator on the arts to try to lay down the law for artists in general. But we live in a time of unprecedented technical and ecological complexity, and one would expect some of the most sensitive and vigorous artists to respond to that complexity. This will lead me to some technical explanation, and to a consideration of wider theoretical issues.

Virtually all art uses technology of a kind. (The exceptions are certain performing arts, such as mime, oral poetry, singing and dance.) Artists who remain aloof from modern technology are, in effect, simply preferring to use the technologies which have been absorbed into traditional art, such as painting, carving and the like. This is a very understandable attitude, since the traditional art media generally allow the artist much greater control over his activity than if he introduces into his art a need for specialized

13

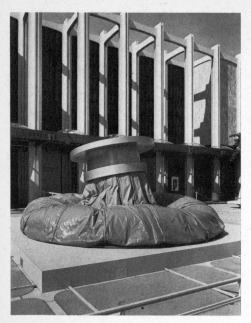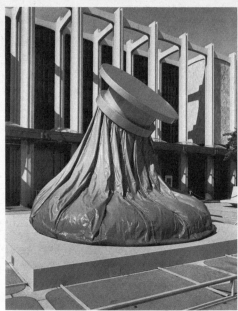

1–2 Claes Oldenburg. *Giant Icebag,* 1971

skills and equipment; also because there are established styles and conventions within which he can operate, recognized by most of his public as the 'natural' channels for art.

Some artists who have made their reputations in fairly traditional media occasionally work in advanced or novel technology when an opportunity arises. The large 'Art and Technology' exhibition, organized by Maurice Tuchman at the Los Angeles County Museum of Art in 1971, included a number of 'one-off' pieces in this category, produced by artists working in, and with, industrial firms in California. For instance, Claes Oldenburg made a giant writhing vinyl icebag, and Andy Warhol used a three-dimensional printing technique to make a field of flowers seen through artificial rain. R. B. Kitaj used the facilities of Lockheed Aircraft Corporation to make reconstructions of nineteenth-century industrial illustrations; but Kitaj is one of the most literary

14

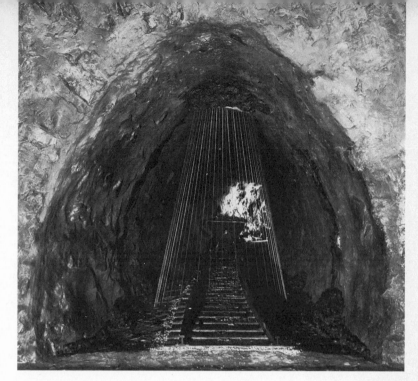

3 R. B. Kitaj. *Mockup: Lives of the Engineers*, 1971

4 Andy Warhol. 3-D flowers and artificial rain, 1971

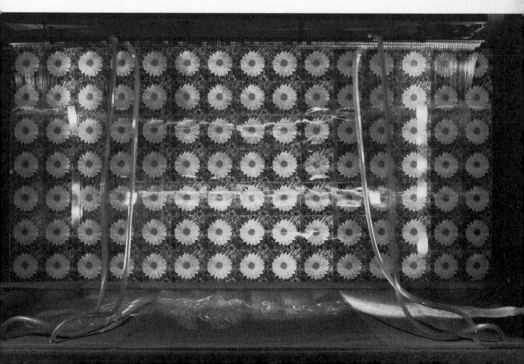

5 Alan Sonfist. *Micro-Organism Enclosure*, 1971

of living artists and has stated that he feels 'utter boredom' when-
ever art and science try to meet (Tuchman, 1971). In such cases,
the meeting between art and technology is casual and *ad hoc*.
My book is largely concerned with more sustained interactions —
where aspects of science or technology have come to dominate
consciousness, or are articulated symbolically. (Warhol, of course,
is an artist who is brilliantly sensitive to certain media such as
painting, film and photography, and I shall mention him later in
this context.)

My own view is that the number of artists who are making really
significant advances in the newer media is very small. But then
there is not much good art about in any medium. I don't want to
make my whole argument for the importance of this field depend
on securing the reader's agreement that Tsai Wen-ying and Alan
Sonfist — artists I shall discuss later — are as worthy of respect as,
say, Donald Judd or Joseph Beuys — both well-respected artists
who are not interested in technology in the way I mean.

So I shall begin by making no critical claims for the work that
has been produced using chemicals, electronic systems, com-

16

6 Tsai Wen-ying. Cybernetic sculpture, 1968 >

puters, lasers and similar techniques. Let us assume for the time being that what is true of three-quarters of it is true of all of it: that it is aesthetically duller and poorer than much work still being done in more conventional media such as painting. Even so, we are witnessing the evolution of new media which are certain to be of great cultural importance. I shall then shift the emphasis from media to expression, from anonymity to personal sensibility, arguing that there is already work being done by certain artists which meets high standards of artistic success.

We should begin by loosely defining a medium. I shall distinguish between the *utilitarian* media, which have social and industrial applications outside the domain of the fine arts, and the *academic* media, such as painting and sculpture and music. It is not that the academic media are exempt from analysis in terms of technical resources (nor, of course, that they always result in what is pejoratively called 'academicism'). But each of these 'arts' has developed with its own self-conscious rituals, genres and conventions over a period, and has severed itself from – though it may often return to – the mundane, everyday functions of visual, aural and tactile patterns. Media in the wider sense ('utilitarian' media) are often adopted by fine artists, but nearly always betray their vulgar functional origins. They are therefore welcomed by those artists who wish to avoid practising academic art in any of its modern embodiments.

CHAPTER TWO

Media Studies and Photography

In 1960 Marshall McLuhan outlined an educational programme for media studies. 'Why have the effects of the media,' he asked, 'whether speech, writing, photography or radio, been overlooked by social observers through the past 3500 years of the Western world? The answer to that question, we shall see, is in the power of the media themselves to impose their own assumptions upon our modes of perception.' It is necessary, he wrote, to 'study the modes of the media, in order to hoick all assumptions out of the subliminal, non-verbal realm for scrutiny and prediction and control of human purposes'.

The reputation of McLuhan has been sagging for some time, and Jonathan Miller's recent essay on him, published in the Fontana Modern Masters series, is a severe and devastating attack. But at the same time it pays the real tribute that McLuhan has convened a new debate on the function of technical media in human communication. McLuhan's remarks about specific media, particularly print and television, have usually been debated piece-meal. The challenge now is first to outline a general theoretical programme of media studies, and then to go back to specific media and suggest how they might be examined.

I shall try to do this here. After proposing what the scope and aims of media studies should be, I shall consider some specific media as examples. For reasons which I shall state, photography appears to be a valuable test-case or model for media studies, both interesting in itself and also relevant to the newest technological media of the twentieth century. These cannot properly be understood unless we go back in history a little.

19

A medium may be defined as any technique used for communication; that is, for the transmission of information from person to person. The word 'information' has a great many senses nowadays (including some technical ones); I shall deliberately use it loosely and non-restrictively. 'Media' therefore extend over a wide range: from the most primitive techniques of drawing, carving, moulding, inscribing, signalling and encoding, through techniques such as printing, photography, film, radio and television, which are familiar parts of the modern environment, up to the most advanced technologies such as 'real-time' data processing, computer graphics and laser holography.

This list suggests the primary scope of media studies. However, it should be noted that there are other ways by which information is transmitted from person to person, which do not at first sight seem to come into the category of communication media but which should probably be regarded as comparable. These methods fall into two categories (at least):

(1) Speech, sign-languages, voluntary gestures and involuntary bodily reflexes exploit the physical characteristics of the human body as a mechanical and topographic complex and hence as a communication medium. Poetry and the arts can help us understand how the body is used as a communication medium (it is an immensely rich one); and disciplines such as linguistics, psychology, physiology, animal ethology and social anthropology can offer valuable insights; but no rigorous theory covering all these aspects yet exists. This is hardly surprising as some of the disciplines that I have named are themselves in a state of 'permanent revolution'. All that needs to be said here is that the combinatory resources and constraints of the human body — everything from the uvula to the sweat glands — can be thought of as a communication medium, which operates either alone or in conjunction with those other media which depend on tools, inventions or properties (in the theatrical sense) external to the body.

(2) Communication was defined above as the 'transmission of information from person to person'. We should probably include

under this heading transport systems, whereby goods and people are physically conveyed from place to place; for they also result in exchange of information. Transport systems are most usefully considered not as media in the same sense as, say, television, but as support systems for media. In the nineteenth century, for instance, the national newspaper grew to be a very important medium of communication, and its support system was the railways. Similarly today, commuter travel as a social pattern supports the city evening paper as a medium, and influences the timing and character of radio and TV programmes; while the speeding-up of mail and news through air transport is too obvious to labour.

In parenthesis it may be added that there is a third kind of medium, where communication is effected not through technology but through some magical or sacramental process. The ritual that invokes such processes consists, like technology, of explicit and ordered procedures. The following reflection by the narrator of Proust's *A la recherche du temps perdu* suggests that the human need for 'communication' overlaps with the need for religious 'communion' expressed in the Mass:

'Then I considered the spiritual bread that a newspaper is, still warm and moist from the recent press and from the morning fog, where it has been distributed since dawn to maids who bring it to their masters with the morning coffee — miraculous, multipliable bread, which is at the same time one and ten thousand, and which stays the same for everyone even though penetrating at once, innumerable, into every house.'

McLuhan has been right to focus on media and propose media studies as a programme for education. Not only is the centrality of science and technology to late twentieth-century culture fairly generally acknowledged, but there is also great interest in the idea of communication as a general principle. Unfortunately, McLuhan often seems to assume that when new media are invented and disseminated they operate directly and almost deterministically on human perception. It is true that he does discuss social and economic

21

factors, but his arguments usually reduce to a claim that certain historical changes were triggered off by a particular technology; for instance, his statement that 'print . . . created the price system' (1962). Any serious programme of media studies must examine technologies and media *as* social and economic phenomena. The question of how far a specific invention – be it the stirrup or the videophone – actually *determines* social and economic processes must always be speculative, even when examined with a greater historical rigour than McLuhan's. But it is possible to describe fairly accurately the social and economic institutions that actually have developed as contexts for a given technology.

The social and economic analysis of media is important, but is not the whole picture. Since the subject of our study is communication, we cannot exclude the closely related issue of creativity. Communication would be solid cliché were it not for the creative activity of individuals – artists, scientists, critics, teachers, and indeed all of us in the course of everyday life – which continuously re-tunes our theories and assumptions about the world, our views of reality, our habits of ordering experience. 'Art is ratified in the end', writes Raymond Williams, 'by the fact of creativity in all our living.' A similar view of art is offered by the influential German artist Joseph Beuys: 'Every human being is an artist – because I am talking about the "point of freedom" that exists within every individual.'

Many people are groping today towards a generalized definition of creativity and communication, irrespective of specific disciplines or media. I think one reason for this concern is that the computer and allied devices have embarrassed us by mimicking what were always thought of as exclusively human mental processes, so that we are forced to try and redefine the boundary that separates men from machines. (I will come back to this point when discussing the computer. The boundary between men and animals is an older anxiety, but here too the question of what we mean by human creativity has been thrown up.) Creativity will, no doubt, always elude full analysis; and it can probably best be understood if we think about it not only in the abstract but also in terms of specific

22

media. The media themselves cannot be understood unless we examine how their history has been affected by individuals and groups with outstanding creative imagination.

A good model for an *approach* to media studies is the attention that Raymond Williams has given to literature and drama, in *The Long Revolution* and other books, and particularly his work on the nineteenth-century reading public and the rise of magazines and newspapers. His approach to the history of the popular press, for instance, integrates the commercial, legal, technical, political and demographic aspects of the subject, while always keeping in mind its relevance to the developing patterns of culture and education that he is concerned to trace at a theoretical level. This approach is admirably complete.

However, Williams's studies of nineteenth-century literate culture do not carry a heavy technological constituent. The medium of print was already old. The changes in this medium that he describes are primarily related to commercial systems of production, distribution and consumption. Innovations like steam printing, the railways and telegrams are all given due weight in his studies, but they are treated as support systems for the growth of the Press, which he sees as the chief change in the communications of the period. This means that he is not interested in, say, telegraphy itself as a cultural institution or medium.

Let us reflect for a moment on what a study of telegraphy as a medium might involve. The curt abbreviated prose customary in telegrams; the popularization of the notion of coding and decoding of information, which is now ubiquitous; the role of telegraphy as a device in Strindberg's play *The Dance of Death* or Henry James's story *In the Cage*; the ritual occasions when telegrams are still sent in preference to cheaper forms of communication, for instance to congratulate or to condole.

Telegraphy, unlike print, is a minor medium. It has given rise to little that could be called autonomous art; though recently there has been a tendency among certain conceptual artists to display telegrams on gallery walls and in art magazines – a way of using the system of telegraphic communication as a vehicle for art. But

telegraphy is one of the technical innovations which, over the last century and a half, have transformed our communications. In the more recent past, technical innovations have been highly specialized, and some of them have affected the lives of only a small minority of people. But others, such as the electronic computer, have already permeated almost every area of social and economic life.

There is now a discipline called technological forecasting, which has tried to set itself scientific standards of enquiry, so that we are now at least a little better equipped than they were in the nineteenth century to make guesses about future developments. It can now take only a few years or decades for a new technical innovation to become a big industry. But the effects of new media on the sensibility and on society are apparently much more gradual and elusive. The aim of media studies should be to get an integrated understanding of media in their social, economic, technical and aesthetic aspects.

We need models to illustrate and test possible approaches to media study. Telegraphy will not do, as it has inspired so little creativity. Print, on the other hand, is a very rich and suggestive model, as McLuhan brilliantly perceived, and much remains to be learnt from it; but as the basic invention of printing was made some five centuries ago, it would be rash to compare it with nineteenth- and twentieth-century innovations without the most cautious reservations. To study print as a vehicle of communication is rather like what it would be to study the wheel as a vehicle of transport. (In McLuhan's own proposals for a syllabus of media studies in secondary schools, he includes the following: 'Let us try and discover any area of human action or knowledge unaffected by the forms and pressures of print during the past five centuries.')

The most promising model for media studies is photography. There has been good work done on its history, but much scope remains for further investigation; and the exercise may suggest some pointers for the understanding of other media, especially the newest ones.

The key discoveries of photography by Daguerre, Talbot and Niepce were all made before 1840. Photography was a chemical

7 L. J. M. Daguerre.
Self-portrait

invention, or series of inventions. The optical principles had been known since the Renaissance, and artists were able to verify their graphic representations of a scene by means of the *camera obscura* with its pinhole that projected an image on to a screen. Still, the invention of photography was evidently a surprising event to many.

Turner is said to have remarked, on being shown a daguerreotype, 'This is the end of Art. I am glad I have had my day.' Aaron Scharf's *Art and Photography* tells the story of the interactions between photography and the visual arts, and covers this aspect of the medium's history admirably. It seems that photography was perceived by academic artists as an anomaly, and therefore as a threat and a pollution. It could be repudiated as beyond the pale, or furtively practised, or reclassified as an academic medium (all of which responses are documented by Scharf). Later on, the photographic 'failures' of the nineteenth century − such as dogs with a sheaf of tails, or ghostly presences − were transmuted by painters like Duchamp into new expressive idioms, which were later to be reabsorbed by photographers like Edgerton and Mili into their medium.

But the story of the interactions between art and photography is by no means over yet. There is a whole line of classic photographers

8 L. J..M. Daguerre. *Still-life*, 1837

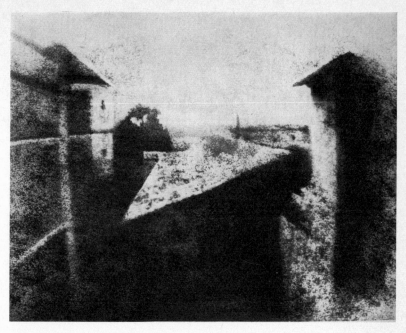

9 Nicéphore Niepce. The first photograph, 1826

of the late nineteenth and early twentieth centuries who, it is hard to deny, were artists of a high order — men like Brady, O'Sullivan, Atget, Steichen, Walker Evans and Hine. Their work is fairly well known, but they are still widely regarded as practitioners of a minor art, at least in Europe. The name of Eugène Atget, arguably the greatest of all photographers, is far from being a household word. One reason for this neglect is that we have had difficulty in accommodating the procedures of photography within traditional aesthetic concepts. Photography challenges our habitual notion of the control which artists are supposed, or were supposed, to have over their resources. It makes us query or redefine such terms as 'intention', 'subject-matter', 'content'; it makes us, first, respect the process of *selection* as potentially creative, and second, accept the intervention of random, or at least unpredicted, events as a legitimate part of the artist's output. For instance, there can be

27

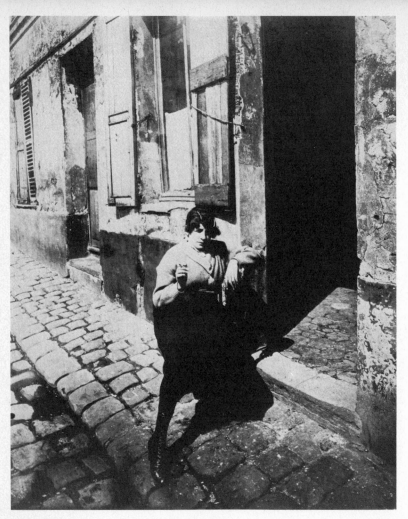

10 Eugène Atget. Prostitute, *c.* 1910

poignant juxtapositions of incident unnoticed at the time of exposure. In photography there is no plastic substance like paint or bronze which the artist manipulates and over which he is supposed to maintain a sort of total control (though something of this control is available at the stage of printing and re-touching). The artist's hand is demoted from being a kind of organism in its own right, and becomes a mere trigger or stabilizer. Andrew Forge

has written (1969) that 'photography is essentially an act of choice on the instant; not the deployment of a language-like convention'; but I doubt if this is a good distinction. Many artists are pre-occupied with aesthetic riddles of this kind, stimulated by such teasing predecessors as Duchamp, but also, I would guess, by the gradual impact of photography on aesthetics. Forge continues: 'The analogy for the photograph from within art did not exist when the camera was invented./Such an analogy was the Duchampian Readymade.'

There is surely no theoretical justification for regarding photography as a medium limited to art of minor quality. It is, crucially, a cumulative art, dependent on the building-up of sequences of related images – and this is part of my answer to Andrew Forge's remark quoted above. People often try to set up a particular photograph as a 'masterpiece' – like Stieglitz's *The Steerage*. A single photograph may 'succeed' by accident. Almost all the great photographers are esteemed for having set themselves a particular path of controlled activity – for instance, Atget's studies of the trades and transactions of city life, or Hine's of the American poor. It should be added that the human and imaginative range of photography is at least as great as that of twentieth-century painting.

An American artist, Mel Bochner, recently said that he considers the studies of animal locomotion by the experimental photographer Muybridge to be among the greatest art of the nineteenth century. The *influence* of Muybridge on art is well known – in his own time, through his studies of galloping horses, and much later, in the painting of Francis Bacon – but it is probably correct, in retrospect, to assess both him and Etienne-Jules Marey as artists in their own right.

It is also worth noting that artists like Rauschenberg, Warhol and Tom Phillips are still finding new ways of using or transmuting this 130-year-old medium. As recently as the 1960s, Richard Hamilton the painter (in his *Whitley Bay* series) and Antonioni the film director (in *Blow-up*) explored the effects of enlarging a photographic image to the limits of legibility, thus making us look at photographs in a slightly different way.[2]

11 (Overleaf) Richard Hamilton. *People*, 1965–66

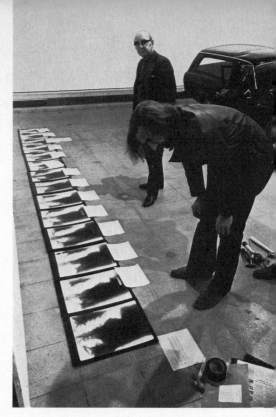

12 John Latham (right), laying out the exhibit of his own X-rays in the Hayward Gallery, London, December 1971, with Stan Vigar, exhibitions manager at the Gallery. The car in which Latham crashed is also part of the exhibit

In a very different idiom, John Latham has recently used X-ray photographs in an original and convincing way as part of an exhibit (shown at the Hayward Gallery, London, in the winter of 1971) documenting his own recovery in hospital from a motor-car accident where he was almost killed.

In short, the creative status of photography has not yet been fully resolved, nor is its aesthetic novelty exhausted. (It is much used in a variety of ways by artists of the 'conceptual' school.) John Szarkowski, director of photography at the Museum of Modern Art in New York, has written that: 'Like an organism, photography was born whole. It is in our progressive discovery of it that its history lies' (1966).

A full study of any medium must not confine itself to aesthetic aspects. 'High photography' must be related to the sociology of the medium as a hobby, ritual, folk art and industry. Improvements

to the techniques are also important: for instance, the introduction of the dry plate in the early 1880s, and of celluloid roll films in 1889, which quickly made possible the snapshot.

The visual arts have already been combed by Scharf for photographic influences and allusions. But literature between 1840 and the present day may have much to reveal about photography. Szarkowski has already drawn attention, in *The Photographer's Eye*, to the daguerreotypist Holgrave, with his advanced views, who is the hero of Hawthorne's novel *The House of the Seven Gables* (1851). The following complex metaphor from Proust's *A la recherche du temps perdu* is also interesting. The narrator is describing how, when he was in love with Gilberte, he found himself unable to remember her face in her absence:

'The searching, anxious, exacting way we have of looking at the person that we love, our waiting for the word which will give us or remove the hope of a rendezvous for the next day, and, until that word is spoken, our alternating, if not simultaneous, imaginings of joy and despair — all this makes our attention towards the beloved too tremulous to obtain from her a clean image. Perhaps also this activity of all the senses at once — which tries to ascertain, with looks alone, what is beyond them — is too indulgent to the thousand forms, to all the savours and movements of the living person whom normally, when we are not in love, we immobilize. The cherished model, on the contrary, moves; one never has anything but failed photographs of her. . . . Not being able to see this well-loved face again, whatever effort I made to remember it, I was irritated to find, drawn in my memory with a definitive exactness, the useless and insistent faces of the merry-go-round man and the woman who sold barley-sugar.'

Proust's delicate metaphor, playing on the ideas of motion and emotion, takes the setting-up of a camera as an analogue not of human vision — Proust's knowledge of the psychology of perception was too great for that — but of human *attention*. Two conditions can lead to the blurring of the image: either unsteadiness of the device (the agitated emotion of the lover) or excessive

sensitivity of film (too great a responsiveness to the beloved's behaviour). Proust's last sentence suggests that whenever we are not in love our memory functions like a kind of photographer's studio (a simile he uses explicitly elsewhere). It is true that the human brain does seem to have a faculty for identification and recognition, especially of human faces that we encounter routinely. Among the chief social and industrial applications of photography today are those which serve or extend this faculty. Photography teaches us to recognize a particular pop-singer or politician, or the analogous physiognomies of beauty-spots and touristic 'sights'; it helps the authorities monitor the behaviour and whereabouts of criminals and aliens (as Andy Warhol's series *Most Wanted Men* observes). Photographs are also exchanged by lovers for reasons which Proust's hypothesis helps to explain: and they alert separated members of a family to changes in each other's appearance, so that the eventual reunion after a lapse of time is less of a shock.

John Szarkowski believes that there are two complementary ways of approaching photography, either as art — a controlled, coherent, measured personal statement — or as a 'great anonymous beast' that has modified our sensibility. The most interesting individual photographers, in his view, are those who have it both ways, whose photos are 'so uncompromisingly like photos that one could approach them as if they were not art at all'. A photo may of course be 'uncompromisingly like a photo' either because it could not have been made by other technical methods, or because it recalls some widespread social application of the medium such as the snapshot or picture-postcard. What Szarkowski particularly admires in certain photographers is that their work does not make an issue of being art (as does so much avant-garde art today).

Szarkowski stresses that, though it may be valid and enlightening to relate the photography of Atget to the painting of Monet or Van Gogh, we should not lose sight of the fact that Atget was a commercial photographer going about a job in Paris for a wide variety of customers such as stage-designers, painters and authors. A study of the professions that he worked for would be interesting.

34

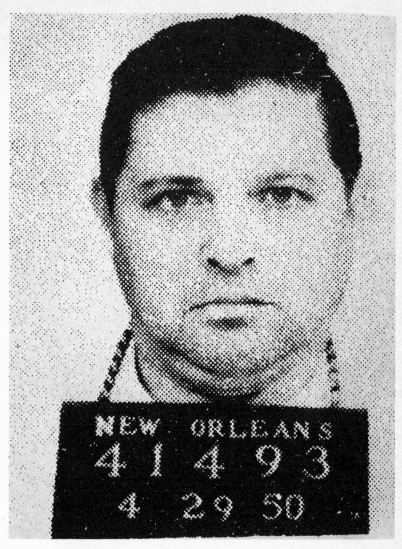

13 Andy Warhol. *Most Wanted Men, No. 7, Salvatore V.*, 1963

More generally, we need a complete social history of photography, including such phenomena as photographers' models and agencies, picture-postcards, family albums, institutional group photographs,)Eton 'leaving photographs' (given by boys leaving to their friends, and pinned on boys' rooms as courtly status symbols), illustrations for printed matter of every kind, new techniques of scientific photography, and so forth.

I hope to have given some idea both of what we do not know about photography, and of how the medium could be studied in an integrated way. The next step would be to relate the history of photography to the history of other media, if such a general theory is indeed possible. McLuhan's theorizing about media has been bold but premature.

With the younger media such as film and television, we know even less than we do about photography. Now we receive instantaneous colour television from the moon. Now we are told that the video-tape industry is going to bring 'canned' programmes into the home, and that education and entertainment will merge, with big-time lecturers becoming international stars. Now a film director, Paul Morrissey, says (1971) that he and Andy Warhol are turning away from the tradition of the 'great director':

'Basically, Andy's always felt his films are an extension of home movies, you know, a record of friends, either a record of your family or a record of your friends or record of your travels. It goes back to the epistolary novel. . . . Films were made the way we make them today in the twenties: they were made by the people who made them the day they filmed them usually.'

Most people would agree that film and television and radio have had very important effects on our culture, though there is much disagreement about what these effects are. Buckminster Fuller calls television the 'third parent' which makes the modern child conscious of humanity and the earth as a whole; other commentators believe it encourages passivity, or violence. It is generally agreed that the cinema film has given rise to outstanding

creativity on the part of directors, actors and technicians, and is a major art form.

My case is that newer media still are emerging which claim attention. To begin to understand them we must consider all their implications, including their aesthetic implications, and this means asking how artists and designers are experimenting with them.

Some of the artists whose work I admire and shall discuss later are choosing their materials and technical procedures idiosyncratically, each defining his own *specific* medium as he works. For instance, there are artists who are building their own electronic systems, or exploiting the properties of chemicals and gases. The heading 'electronics' or 'chemicals' is here too broad for us to be able to learn much from a media-oriented approach; it is more rewarding to consider such work as personal expression. Often the actual technical means used are very simple, and what is interesting is the originality of the underlying idea. (In other cases, technical resources have been stretched so far that the art project has come to grief.)

The medium within which some of these artists still think of themselves as operating is the medium of sculpture, broadly defined as art in three dimensions. Many 'sculptors' today interpret the term very broadly to include work which incorporates verbal and other support material. With the introduction, too, of sound and other sensory effects into sculpture, the term has become too vague to be serviceable. But the academic tradition of sculpture, like those of painting and music, still offers accumulated reserves of technique and experience on which artists can draw when they wish; and we assume this tradition as part of the expectations shared between the artist and his public. The most rewarding criticism of painting and sculpture today is probably that which asserts the primacy of the medium: both the basic facts of working in two and three dimensions respectively, and the specific properties of different kinds of surface, paint, modelling and carving, and so on.

There are two new media which demand to be discussed in terms similar to those suitable for media like print, photography or television. These are the computer and laser holography.

37

Both are so new that I shall have to argue, first of all, that it is indeed valid to think of them as communication media. They are comparable to photography because of the novelty both of the facilities which they offer to the experimenter, and of the constraints which they impose on him. As with photography, it may be many years – though not, probably, as many as 130, given our relative self-awareness today and the acceleration of technical innovations – before the full effects of the newest media on sensibility and culture work themselves through.

These technical innovations are in a full sense communication media, as I shall try to explain; and they must be contrasted with others which are absorbed with comparatively little effort into fine art, like fibreglass, acrylic paints, metallizing processes, neon-tube lighting, and anodized aluminium. All too often these merely serve the need of artists to acquire the distinctive personal style demanded by the art world. Jack Burnham has described in *Beyond Modern Sculpture* a satirical sculpture called *Hybrid* made in 1965 by Gerald Laing and Peter Phillips from painted, neon-trimmed Plexiglas on an aluminium base, the result of a computerized market research study of 137 art consumers – a 'reenactment of the motor industry techniques'. Many of the exhibits in the 1971 Los Angeles 'Art and Technology' show appear to have been aesthetically conventional, however complicated they were technically.

Photography must have given some people a widespread feeling of liberation, as well as challenge; and a similar feeling is experienced by pioneers in any new communication media. Those working with the computer or laser holography enjoy at present a specialized and esoteric form of exhilaration, and are hemmed in by practical difficulties, but if I am right their work calls for wider attention.

'Good art' is not what we are likely to find there, in one sense. In another sense, the first work done in any new medium is bound to be good because it is setting its own criteria of success. However, I offer the 'media-oriented' approach not as a total response to art, but as one useful perspective on the relations between art and

38

technology. After considering the computer and laser holography as media, I shall discuss artists whose work does not fall neatly under the heading of a specific 'functional' medium, but is generally related to some aspect of science and technology. For instance, as we shall see, many of these individual artists have in common a broad awareness of their work as systems undergoing transformations in time. Thus from considering artistic expression as one of the many factors contributing to the history of media, I shall proceed to focus on some examples of artistic expression itself as it develops *through* media in response to the complexities of the modern environment.

All art forms and communication media may be presumed to have certain principles of organization in common, as well as properties peculiar to each. Ideally, the general principles of art and communication and the specific properties of media should be investigated as a single exercise.

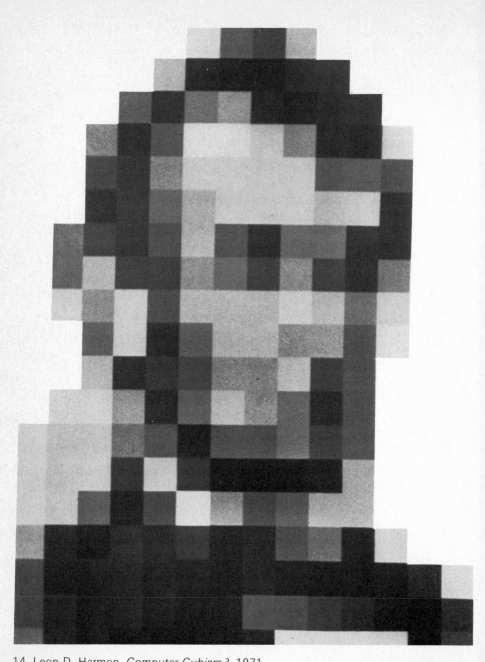

14 Leon D. Harmon. *Computer Cubism?*, 1971.
The purpose of this experiment by Bell Laboratories is to facilitate the transmission and
computer storage of visual information by resolving the image into a small number of
units of varying shades of grey. In this case, with 200 squares in 16 shades of grey,
the subject should be just recognizable if you squint or hold the book at arm's length

The Computer — or Information Processing Technology

All over the world there are people who are applying the computer and its related disciplines to 'art' — graphic displays and print-outs, film animations, interactive systems, architectural designs, music, verse and so forth. As I have suggested already, the movement has produced little that can be taken very seriously as art *per se*. I propose to consider the phenomenon as a commentator towards the end of the nineteenth century might have considered photography. The analogy does not go very deep, but it is the method of media study that is important.

Let us ignore the contribution of artists, for the time being, and consider merely the social and economic implications of the computer. These implications have by no means been neglected; there is an extensive literature on the subject. However, it is extremely confusing; and I shall try to introduce some clarity.

Photography can best be understood if we realize that it was experienced, at least in the nineteenth century, as an anomaly: not art as art was generally known, but satisfying many of the criteria by which art was normally judged — for instance, being 'true to life'. We can look at the computer in a similar way. A lot of the emotion that the computer has stimulated — enthusiasm, hope, suspicion, hatred — has been due to its anomalous status.

On the one hand, the big computer manufacturers like I B M have spent vast sums on training-courses, sales literature, films and the like, designed to reassure their potential customers and users — straightforward, practical men — that the computer is just another tool like the typewriter. Adages abound like: 'You can only

get out of the computer what the programmer puts into it', and 'Garbage in, garbage out'. These reduce the layman's awe of 'electronic brains' (as they used to be called) and make him realize the necessity of a competent programming and operating staff in any computer installation. In the eyes of many users of the computer — and we are all users of the computer in a sense, even if we never set eyes on one, through our relations with the big institutions that use them — it has been successfully fixed in this menial, passive role: a complicated tool serviced by gangs of highly trained, well-paid technicians.

But the computer's obstinate affinities with human mental processes keep bobbing up. This is hardly surprising, as the analogy between human thinking and machine logic is not a fanciful accretion to the folklore of computers, but has always been present in computer theory since before the Second World War. In the literature of abstract computer theory, we find sentences like the following (from Kleene's *Introduction to Metamathematics*): 'The behaviour of the computer at any moment is determined by the symbols which *he* is observing, and *his state of mind* at that moment.' (My italics.)

A great deal has been written about the relationship between 'natural intelligence' (that of humans and animals) and 'artificial intelligence' (that of computers and allied devices). Although the term 'artificial intelligence' is a rather provocative concept which could perhaps be replaced by other, more neutral terms, it would be impossible to give a full account of the significance of the computer without mentioning the interdisciplinary science of cybernetics or general systems theory.

Cybernetics, the science of 'control and communication in the animal and the machine', as it was defined by Norbert Wiener in 1948,[3] has provided some very influential ideas over the last two decades. It works on the assumption that electronic, mechanical, biological, economic, industrial and other classes of system belong to a larger class, the class of all observable systems. A system may be defined as 'any network of events in time with recognizable order'. One cybernetician, Ross Ashby, goes further (1956):

'Cybernetics . . . takes as its subject-matter the domain of "all possible machines", and is only secondarily interested if informed that some of them have not yet been made, either by Man or by Nature. What cybernetics offers is the framework on which all individual machines may be ordered, related and understood.'

The term 'system' is now more commonly used than 'machine' (in Ashby's extended sense of 'machine'). Parenthesizing the physical characteristics of a system's parts, cybernetics studies the interaction between the parts of a system, whereby one part controls another. In a word, it studies organization.

Norbert Wiener suggested that ours is the age of cybernetics, as the seventeenth and eighteenth centuries were the age of clocks and the nineteenth century the age of steam. Ours is not the first age to be fascinated by the relationship between mechanical systems on the one hand and organic or social systems on the other hand, as may be confirmed by a reading of the seventeenth-century philosophers Descartes, Hobbes and Leibniz. It is often and rightly claimed that the technology of the computer is helping to shape society; but the claim could equally be made that this technology is an expression of our *Zeitgeist*, the product of a society which needs a certain set of inventions in order to classify, analyse, manipulate and monitor the behaviour of individuals.

Cybernetics has undoubtedly contributed a great deal already to our appreciation of the relationships between disciplines, if only in providing a common language. It is doubtful, for instance, whether our present concern for ecology on a global scale would be so articulate if cybernetics had not taught us to think of the biosphere as a single system consisting of hierarchies of sub-systems. In a completely different area of biology, the bio-chemistry of genes, metaphors from cybernetics are also present; and new metaphors have always been crucial to scientific advance. However, the applicability of cybernetic models to complex natural systems, such as the human brain, has been too confidently asserted in the past; and their application to such very delicately organized systems as human societies can be positively dangerous, since the model is often laden with ideological assumptions.

43

There seems at present to be a greater caution in the claims being made by researchers for the analogies between mechanical systems and biological or social systems. The 'science' of cybernetics is thought not really respectable by many academic scientists, though many concepts associated with cybernetics have become commonplace. Many biologists, neurophysiologists and social scientists have questioned the claims of cyberneticians, or insisted on the need for developing more rigorous hypotheses; but if there has been one development that has done most to call in question the progress of cybernetics since the publication of Wiener's *Cybernetics* in 1948, it has probably been the new linguistics, which has nonetheless used a cybernetic vocabulary. Chomsky and others have shown that human language, and any mental processes which we may suppose to be dependent on it, are completely beyond the capabilities of present computer technology. Certainly the technology of automatic language translation, about which much was once heard, has had to go back to fundamentals during the 1960s, and a large financial investment in the United States was completely written off. 'Natural language' — as human language is called, to distinguish it from artificial languages such as those used by computer programmers — may be a key to the understanding of intelligence and creativity.

It is fair to add here that there are those who believe that eventually the computer will be able to process natural language. The controversy depends on some abstruse points of mathematics. It is also important that the very advances in linguistics over the last few years were made possible by the development of cybernetics; I shall revert to this point in Chapter Seven, which is devoted to linguistics.

This book is not the place for an up-to-date survey of the present situation in artificial intelligence research, cybernetics, and man/machine communication. What I wish to emphasize here is that the computer is an anomalous entity. On one wing are the interests of the computer industry, expected by its stockholders to maintain an annual growth rate of about 30 per cent (at least till the recent recession in the USA), and therefore protecting the public from

any disquieting speculations about the true nature of its mechanical slaves. (Not surprisingly, there have flared up fantasies, fanned by science-fiction writers, about the day when machines rise up to claim their rights.) On the other hand, there are those who are fascinated by this machine which is an extension not of the human sensory-motor functions, like most other technology (that is to say, of functions for sensing and manipulating the environment), but of the human brain itself.

The posing of riddles like: 'Can machines be creative?' or 'Are computers merely tools?' can be a waste of time, though many miles of print must have been devoted to them. The answers are buried in the vocabulary used to phrase the riddles. We can only define what it is to be 'creative' in terms of what a machine is *not* capable of making or doing. For instance, computers cannot handle natural language, and this fact is held by some (rightly in my view) to be very relevant to a provisional definition of human creativity. As more and more is achieved by machines — for instance, composing a *haiku*, or winning a chess-game, or diagnosing illness — we say: 'Oh, if that's all you mean by creativity, that wasn't what I meant.' Similarly, the concept of a 'tool' is dependent on the attitude of an observer or user. Men are often treated as tools by the corporation that employs them (or which fires them to rent a computer to do their jobs); but this does not mean that they are treated as tools by their wives and families. An accountant or a doctor uses a computer as a tool to help him in his work. However, my own experience of working technically with computers and their software or programming systems (now as important and complex as the hardware) is that one comes in practice to treat them as kind of equals in a working relationship — idiosyncratic, obstinate and literal-minded maybe; but not without a dry wit which is often celebrated in computer jokes.

A typical example of a computer joke is the following. An operator, exasperated by technical difficulties, keys in the message GOD DAMN YOU on the typewriter console of a computer system. The operating system (part of the computer's software) replies through the typewriter GOD NOT VERIFIED. (This might

actually happen because the operating system would check each word to see if it recognized it; GOD would be the first word it encountered, and its reaction would be to print out an error message to warn that the input could not be processed.)

As Mary Douglas has written, 'If there is no joke in the social structure, no other joking can appear.' The essence of most computer jokes is that, wherever we choose to assign the computer in the 'social' hierarchy, as slave or oracle or working-partner, its anomalous nature will assert itself.

Computers are often referred to familiarly by people in the trade as animals or brutes, idiots or morons. Many 'housekeeping' programmes — those which perform routine functions in the organization of information — are thought of as consisting of a number of conceptual officials, giving and obeying orders in a hierarchy: the input/output monitor, the supervisor, the queuing manager, the executive, the linkage editor, the interpreter, etc.

The computer is not thought of by everyone as a communication medium, and I must establish that it is before going any further. ⁎ The word 'computer' has grown up rather by accident and is in wide colloquial use. Unless otherwise qualified, it is generally used (as I have used it in this book) to signify the *general-purpose digital computer*, as opposed to (*a*) special-purpose systems built for a particular function, and (*b*) *analogue computers*, i.e. devices to perform calculations about a real system by constructing a model or 'analogue' (usually electrical) of that system and making measurements on it. A digital computer, by contrast, converts all information internally into digital information, usually in the binary system, which consists solely of zeros and ones. Digital computers constitute a much larger industry than analogue computers and are much more versatile devices.

But the term 'computer' is seldom used in strict technical language. A digital computer system is more exactly described as a *data processing* or *information processing system*. A large proportion of any such system is composed of programming systems or software, i.e. a purely logical structure of information conceptually independent of any mechanical devices ('hardware') that it may

happen to be stored on. The hardware itself includes *peripheral devices* for input and output (card readers, line printers, console typewriters, and sometimes an expensive system of cathode ray terminals, graph plotters, speech synthesizers, etc.), and *storage devices* (usually magnetic tapes or discs or drums) for maintaining 'files' of information. The only part of the whole which actually performs 'computation' on numbers is the *central processing unit*. Even here, numerical computation or calculation is not required for all types of job. Though much data processing is numerical, particularly in scientific and financial applications, a good deal is in symbolic, alphabetic or 'alpha-numeric' (both alphabetical and numerical) form: for instance, when a computer is used in the management of a technical information service in a laboratory, or for a world-wide airline reservation system. (As I have noted above, a digital computer works *internally* by converting *all* information, numerical or non-numerical, to numbers; but this is only of concern to the computer's more intimate acolytes.)

The computer is best seen as a specialized extension of certain functions which the human brain can manage but less efficiently. If I were asked to define very briefly what the digital computer's most *distinctive* ability is, it is that it can keep its place. We keep our place in a book by dog-earing a page or putting in a marker. The computer keeps its place by means of a myriad electronic 'flags' which tell it what to do next. The computer does also have the ability to work very speedily, but so has the human brain in a different way. In terms of 'input/output capability' we are enormously superior to any computer system. What the computer can do better than the human brain is maintain accurately as many totals, sub-totals, cross-references, indexes and tabulations as we care to tell it to. This applies to all information processing, whether of letters, numbers or other symbolic codes.

The computer is thus a communication medium in much the same way as photography. If the camera extends our ability to recognize or *match* visual images such as faces, it may be speculated that the computer extends our ability to structure or organize information so that matching of symbols is made more efficient.

47

Hence it acquires a certain limited but powerful competence which the human brain has abdicated to it.)

Like other major communication media, the computer has become a major social and economic institution. A measure of its economic importance is the disrupting effect of technical change within the industry. The computer industry is often thought of as new and radical. It is true that it employs many young and thrusting professionals, and that it often succeeds in imposing radical change on its customers' administrative systems. But its own present economic situation is similar to that of the motor-car industry, in that technical innovations have a wide-ranging economic impact. I B M, for instance, after some unhappy experience in overreaching itself technically during the 1960s, now keeps careful control of the pacing of its technical innovations (probably suppressing much of its research) in order to protect its customers from disruption, thus securing continued profitability for itself; while its smaller competitors have to devote a large part of their efforts to developing products 'compatible' with I B M's. Like the motor-car industry, the computer industry is heavily committed to locking itself into everyone's way of life. The motor-car industry is as entrenched as it is because society has made massive capital investment in roads and engineering plant; the computer industry because almost every economic or social transaction one can think of – from buying a packet of frozen peas to getting married – now becomes a piece of information for a computer system, so that we are all plugged into the computer industry as electrical appliances are plugged into the national electricity network. Computers are to a great extent the servants of large administrative, commercial and military institutions; this fact has greatly influenced our image of them. But there is no necessary reason why the computer could not be used for different social ends: if people insisted enough, computers could be used to enhance personal liberty and autonomy.

One or two design theorists like Nathan Silver are urging that there should be a huge expansion of the 'do-it-yourself' and mail-order industries, so as to give the consumer the facility to select

parts and build up assemblies; thus everyone could become his own designer and the manufacturers' restrictive tendency to standardize would be curbed. The computer's ability to store information about parts and sub-assemblies, deliver it selectively to order, and communicate the consumer's requirements directly to the manufacturer, could theoretically assist such a service. Whether it will do so or not is more doubtful, and depends on social factors. My point is that if we dislike bureaucracies and the industrial-military complex, it is them that we should try to change: the computer itself could serve other social ends, as a number of people in the 'Counter-Technology' branch of the American underground movement have perceived. (This sub-movement finds expression for its ideas in such publications as *Radical Software*, though this paper is more concerned with video than with computers, and leans heavily on Fuller and McLuhan.)

The economic importance of the computer industry has given its professionals, especially those most highly qualified, a position of great latent economic and political power, though being for the most part politically torpid they are seldom aware of it or choose to exercise it. Unlike airline pilots — who have demonstrated the power of a small body of indispensable experts to bring a world-wide organization to a standstill — computer programmers and operations managers and systems analysts have tended to form no unions or comparable pressure groups, presumably because their job-market is very mobile. With the recent recession in the USA and a surge of unemployment in the technical professions, there will probably be a trend towards unionization.

Some computer professionals have taken steps to assume the sense of responsibility concomitant with power, though they have not yet realized the political power itself. The rise in America of the idea of the social responsibility of the computer professional has been discussed by Gustav Metzger (*Page* 11). This concern has focused on the use of computers in war technologies — rightly, because the fast expansion of the computer industry since the war has been partly due to military expansion — and on the use of data banks by institutions to monitor the private lives of individuals.

The full social implications of the computer are beyond the scope of this book. What I have tried to do here is suggest that when the artist decides to use a computer, even as a toy, he is in fact using a communication medium with a short but rich history and a complicated social context, which cannot but affect his work.

I have mentioned that at one extreme the computer is regarded and treated by the public as a tool, and at the other extreme as a potential rival to human supremacy. Art — being always a multifarious and irrepressible phenomenon — expresses all these gradations of human attitudes towards the computer. In the following pages I shall cover some of the applications of computers by artists. These will be mainly artists who use visual output. There are a number of musical composers, such as Iannis Xenakis and Pietro Grossi, who use computers in their work; but it would be hard to discuss them except at a technical level which I wish to avoid in this book. (A more rigorous study of 'computer art' would probably classify work by type of information processing or 'programme', rather than by type of output.)

The easiest work to discuss, partly because it reproduces easily, is computer graphics. In the computer industry, this term is used to describe (1) output devices, whereby images can be drawn under computer control, for instance the graph plotter; (2) devices such as cathode-ray terminals, used for both input and output, and thus for interaction between user and computer; and (3) other related techniques, such as photocomposition for the printing industry. These graphics techniques are used in many industries for a variety of applications. Millions of television viewers have seen how the landing of a lunar module on the moon is simulated, in astronaut training-courses, on a cathode-ray terminal. The use of graphics techniques by architects, designers and planners of the future is discussed by Nicholas Negroponte in *The Architecture Machine* (1970).

Artists tend to use the term 'computer graphics' more vaguely, to mean any visual outputs produced under computer control, or even those which are executed manually according to instructions

issued by a computer. The confusion arises because 'graphics' has a well-established meaning in the world of art and design, independent of the term's usage in computers. Some 'computer graphics' (in the arts sense) are printed directly by an ordinary line printer such as is found in almost every computer installation.

Theoretically, a commentator like myself could approach a new medium such as the computer in a purely descriptive and non-evaluative way. This might seem feasible for a study of computer art, since it is relatively young. Alan Sutcliffe, chairman of the Computer Arts Society which was founded in London in 1969 after the success of Jasia Reichardt's exhibition 'Cybernetic Serendipity' at the Institute of Contemporary Arts (I C A) in 1968, writes that the original policy of the society was one of neutrality and inclusiveness (*Page* 13).

'This is why we chose the commonplace name of the society, even while agreeing that the term Computer Art was to be deprecated. It is still a convenient shorthand word for "creative work in which a computer has been used". I felt that any such work deserved a showing and its author a hearing. No matter how trivial, I thought it was significant that someone had used a computer to make something.'

Sutcliffe is now ready to take a more critical line towards such works. It seems to me that in practice the suspension of critical evaluation does not work, as it is hard to keep up the interest of other people, or indeed one's own, in any subject unless some criterion of merit however sketchy is offered. The Computer Arts Society has run into this very difficulty.

The term 'computer art' is itself a provocation (even more than 'artificial intelligence') because the very terms in which we often characterize art — 'humanity', 'warmth', 'spontaneity', 'sincerity', 'originality' and so forth — are laden with implicit prejudice against the values of which the machine is a symbol. However, several experimental psychologists, such as Max Clowes of Sussex University, are interested in computational techniques not for their own sake or for practical data processing purposes, but as a means

of studying the mind, and particularly the ongoing creative process that we call perception. Paradoxically, such researchers are resorting to machines in the effort to redefine human creativity. There is a chance that artists will eventually find computational techniques equally stimulating.

Some examples of computer art are mainly interesting as curiosities. Among these I would class ART 1, a computer programme devised by Professors Katherine Nash and Richard H. Williams, of the universities of Minnesota and New Mexico respectively (see *Page* 7). The logic of this seems to be that the computer industry is emphasizing more and more the value of programming 'packages' for various professions, so that scientists, dentists, sales managers and many others can use the computer effectively and easily without having to bother themselves with software or hardware 'internals'. Nash and Williams conceive of the artist as someone who wants to make a 'personal statement' in the form of various squiggles, spheroids, etc. In fact, he could draw them for himself with a ruler and pencil in two minutes. Nash and Williams think it helpful to provide him with a set of programming facilities so that he can make these squiggles, etc., at much greater expense and more laboriously. The justification claimed is that the artist does not have to find out about computers before using the programme. There is, I think, a fallacy here: that of regarding the artist as a specialist with pre-defined professional needs. There must, according to this argument, be a special set of programming facilities for artists just as there is for architects, doctors, accountants and so on. ART 1 would be more acceptable if it were presented as a teaching-aid for use in education at an elementary level. But it is representative of the kind of thinking that the computer has stimulated: in this case, an attempt to assimilate art to the specialist professions that the computer serves. The same is being done, using more advanced programming techniques than Nash and Williams, by Hiroshi Kawano in Tokyo, who makes enormous 'colour mosaics' with a computer, in the style of Mondrian.

Here I should also mention Lloyd Sumner, one of the few 'computer artists' who actually make a living from their work.[4]

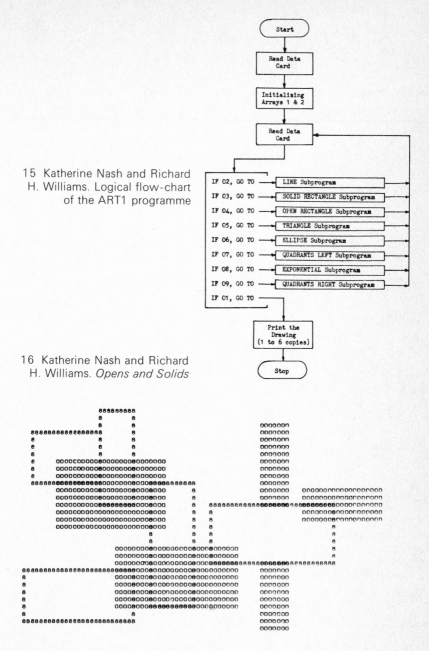

15 Katherine Nash and Richard H. Williams. Logical flow-chart of the ART1 programme

16 Katherine Nash and Richard H. Williams. *Opens and Solids*

Sumner uses a computer and graph plotter to produce designs to which he adds captions, sometimes making the whole into Christmas cards, the computer enabling him to 'personalize' each card by making it slightly different. Sumner's designs are inventive technically, but most of them could have been executed with much simpler means, sometimes just a ruler and compasses. Sumner is more interesting when he animates his designs in a computer-animated film, which gives them a new energy.

In a similar category to Sumner's work are the graphics sponsored by California Computer Products Inc., who manufacture the CalComp graph plotter. These include *The Snail*, a fine use of the moiré patterning effect, but usually ruined by its presentation, for CalComp exhibit this and similar works in pompous wood frames with small gilt labels, as if to give them the respectability to adorn some boardroom.

There is no need to be severe on Lloyd Sumner or CalComp. Both are using the new medium to produce rather conventional artefacts – for the bourgeois home and the boardroom respectively – but their enterprise is significant as part of social history. Similarly, photography was used in the nineteenth century to emulate the established genres of painting and engraving.

17 Hiroshi Kawano.
Artificial Mondrian
(left-hand half).
A HITAC 5020
computer, programmed
in FORTRAN (a
'language' which
permits users to
programme the
computer without a
knowledge of its
internals), and line
printer were used.
Colours – red, yellow
and blue – were
added manually

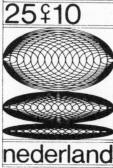

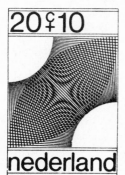

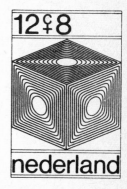

18–21 R. D. E. Oxenaar. Computer-
aided stamp designs, 1970

22 Lloyd Sumner. *The Rotunda*, 1969.
Computer design inspired by Thomas Jefferson's building at the University of Virginia.

23 Lloyd Sumner. Computer Christmas card design, 1970

CONSPIRED ABSTRACT OF THE CHRISTMAS SPIRIT

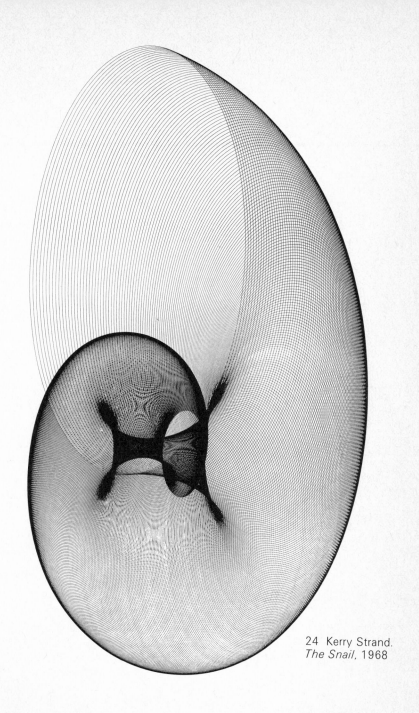

24 Kerry Strand.
The Snail, 1968

There is a clear parallel between the experimental use of photo-graphy in the nineteenth century and experimental computer graphics. The use of camera lenses to make distortions and trick photographs seems to have been a favourite Victorian pastime, as Aaron Scharf has described (1965, 1968). This was a frivolous parallel to the careful photographic experimentation by Muybridge and Marey. Much that has been produced in computer graphics does not deserve to be called 'experimental' except in a loose sense, but merely explores the novel facilities offered by the computer, chiefly its readiness to perform very easily – by 'keeping its place' – a large sequence of repetitive procedures which would be in-tolerably tedious to do manually. Thus *Return to a Square*, a computer 'metamorphosis' by Masao Komura and Kunio Yamanaka, has little artistic merit but is ingenious and makes one feel that the computer has earned its keep.

It is not hard to conceive that casual experiments like *Return to a Square* might fertilize the minds of new artists some day, like the photographic tricks and distortions of the nineteenth century. But certain artists like Frieder Nake and Vladimir Bonačić consider their work experimental in a more sustained sense. They are influenced by a school of aesthetics which has found more popularity in Germany than elsewhere, and to which the British seem as in-different as they ever are to abstract theoretical constructs. This school has attempted to apply mathematical principles to art and poetry. It is much indebted to the work of an American mathe-matician, G. D. Birkhoff, in the 1930s. Birkhoff tried to express the 'aesthetic value' of an object by means of a formula with two basic variables, 'order' and 'complexity'. Those objects which were likely to be preferred aesthetically were those where the amount of order was high and the amount of complexity low. More recently, Birkhoff's mathematical models (which were crude) have been replaced by 'information theory', though there are still some groups where Birkhoff's 'aesthetic measure' is taken seriously, for instance the $\Sigma 1$ group in Timisoara, Romania. Information theory is a statistical technique introduced by Claude Shannon in 1949 and much used since, both theoretically and practically, in the field of

25–26 Masao Komura and Kunio Yamanaka. *Return to a Square* (a and b), 1968

computers and electronic communications. The best-known con-
temporary exponents of the mathematization of aesthetics are
Max Bense, professor of philosophy at the University of Stuttgart,
and Abraham Moles, director of social psychology at Strasbourg
University.

Max Bense writes that mathematical aesthetics is a process
which is 'devoid of subjective interpretation and deals objectively
with specific elements of the "aesthetic state" or as one might say
the specific elements of the "aesthetic reality"'. These elements
include meanings as well as sensuous or formal qualities. Bense
proposes a 'generative aesthetics' which would explain how
aesthetic states are generated in the same way as a generative
grammar in linguistics attempts to explain the logical processes by
which sentences are performed and interpreted; but a prior stage
of analytical aesthetics is held to be necessary. The main mathe-
matical techniques proposed by Bense are semiotic (the study of
signs, originated by C. S. Peirce and others), metrical (concerned
with forms, figures and structures), statistical (concerned with the
probability of appearance of elements) and topological (concerned
with the relations between *sets* of elements). Unlike some other
comparable theorists, Bense cannot be accused of oversimplifying
the issues.

59

Abraham Moles, an eloquent speaker and a prolific and versatile writer, has been influential in Europe as a promoter of the concepts of information theory and cybernetics (1968, 1971). There is no doubt that certain of these concepts − such as 'constraint', 'variety', 'redundancy', 'entropy' − help in clarifying ideas about art and perception, and should by now be part of the vocabulary of anyone who professes to be an expert on theories of communication. If pressed, Professor Moles admits that his theories are embryonic. It remains to be seen whether the attempt to found an exact science of aesthetics is valuable at all. So far, few if any actual hypotheses have been offered to test against concrete aesthetic experience, except ones like Birkhoff's which are implausible. However, disciples of Bense and Moles believe that there is a Copernican revolution round the corner, and that we sceptics will be proved wrong eventually. I should add that Moles's own definition of art as a 'programmed sensualization of the environment', and his emphasis on art as a game (the 'ludic' principle) seem to me somewhat superficial.

Frieder Nake, who has been much influenced by Bense, believes that it is necessary to abandon art for ten years and concentrate on visual research, by which he means research into the aesthetic fundamentals of visual perception. The computer is used as a tool in this research. My own view of such research is sceptical, firstly because it seems completely inadequate to the complexities of its subject (since in practice only the most simple problems are actually quantified), and secondly because the attempt to isolate 'aesthetics' as a self-contained subject (things being held to possess 'aesthetic properties' distinguishable from other properties) seems to me mistaken. This could be Anglo-Saxon prejudice. Frieder Nake was one of the first to work in computer graphics, in 1963 at Stuttgart. He believed that the computer could simulate 'intuition' by the automatic generation of pseudo-random numbers. In 1970 he announced that he would no longer exhibit his work, and in June 1971 he denounced the whole concept of works of 'computer art' as a decadent fad, while adhering to the principles of visual research.

60

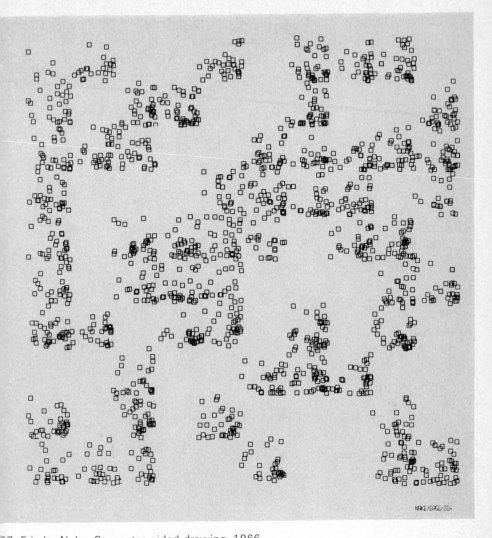

NAKE/EP56/ZG4

27 Frieder Nake. Computer-aided drawing, 1966.
The drawing is the result of producing uniform small squares with a kind of regular
irregularity specifically suited to a computer's patience

Vladimir Bonačić is sceptical about the applicability of information theory to aesthetics, since it takes so little account of semantics. But he approaches visual phenomena in a mathematical and systematic way. He is head of cybernetics at a research institute near Zagreb, Yugoslavia. He has made two light spectacles in squares in Zagreb. These work under the control of programmes generated with the help of a computer (i.e. the spectacles themselves are not directly under the control of a computer), and give a permutative effect rather like an automated and visual analogue of English bell-ringing. Bonačić has also made a small 32×32 matrix of flashing lights which can be set so that its sweeping patterns do not repeat themselves for 32 years. Here the ingenious mathematics is an integral part of the work, appealing to a numerate aesthetic (just as we say that an artist like Kitaj appeals to a literary aesthetic), and its conceptual integrity has to be acknowledged.

Illustrations 39–44 are simple examples of computer graphics which seem to me original. One is from the *Flora* series by Petar Milojević, a Yugoslav who now lives in Canada. These look rather ordinary until one considers the programming concepts involved. They represent in a realistic fashion the branching of trees and

28 Vladimir Bonačić. Light-spectacle above a store
in Kvaternikov Square, Zagreb

29 Vladimir Bonačić. Light-spectacle in the main square of Zagreb

plants, and are executed with an IBM 7044 computer and a Cal-Comp plotter. Milojević uses the computer to generate a Fibonacci series — where each new value is half the sum of the two preceding values — to control the branching, since it has been suggested that some plants grow according to this formula. This idea in itself would not justify the use of a computer.[5] The added originality in Milojević's idea is that with only a slight change in the programming logic he can change the floral texture, so as to give potentially the effect of an immense variety of plant species. This is as near 'art' as anything I have seen from computers, a poetic hint that the parsimony of nature and the exuberance of nature — economy and richness — could be one and the same. In the background lies an analogy between the computer's programming instructions and

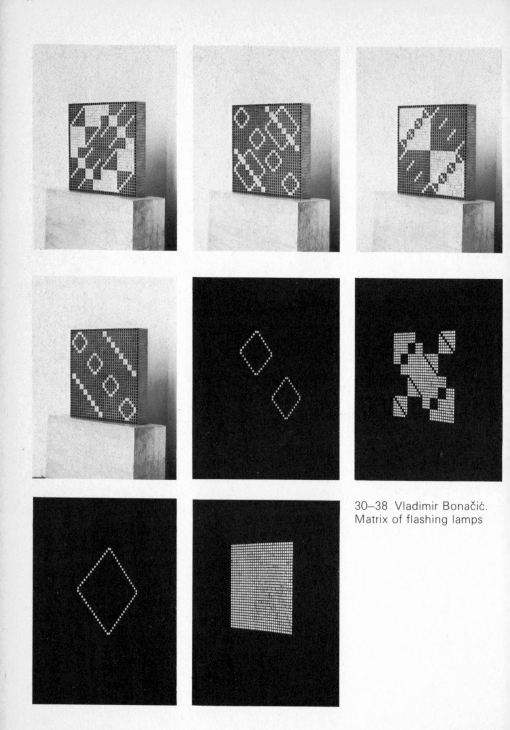

30–38 Vladimir Bonačić.
Matrix of flashing lamps

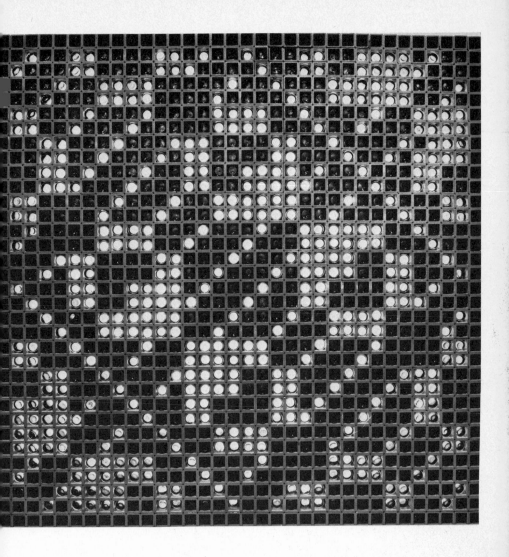

the genetic code responsible for evolutionary specificity and variety; but this analogy is implied discreetly, rather than asserted.

The rest of Petar Milojević's graphic output is more pedestrian, and it is possible that I am reading into his work intentions which he would repudiate. Whether this would make the work less poetic is a matter for aesthetic debate. One further point is worth making. Without a verbal commentary, it would be hard to distinguish *Flora* from a competent but ordinary manual drawing. Verbal commentary – an explanation of the process that generated the object – is integral to the art and not a matter of mere external presentation. Here *Flora*'s situation is similar to that of much other contemporary art that has nothing to do with computers. Over recent years there has been a growing emphasis on the 'support languages' through which art is presented or described. This is partly because artists have wished to bypass critics and other writers on art, partly because they have wished to add explicative and elucidatory verbal material to the central visual or other core of the work. An articulate, if often obscure, position is that of the Coventry *Art-Language* group, who believe that the 'central core' – 'direct read-out from the object' – can evolve to 'include or assimilate one or other or all of the support languages'.[6] The full case of the *Art-Language* group results in the disappearance of the actual perceptible object, so that we are left only with the support languages – to the dismay of the art-loving public. One need not share the group's extreme conceptualist position in order to assent to the theoretical point about support languages.

The second example of computer graphics I illustrate is by two Brazilians from São Paulo, Waldemar Cordeiro and Giorgio Moscati, an artist and a nuclear physicist respectively. The set of four graphics is called *Derivations from an Image*, and has as much to do with photography as with the computer. An image – in this case a Valentine's Day poster – is fragmented by the computer into a matrix of small fragments, each of which is given a 'darkness value', from 0 to 7, depending on where it belongs in the 'grey' spectrum between white and black. The computer (an IBM 360/44) then performs transformations on the numbers, and a

39 Petar Milojević. From the *Flora* series 1968

0 Waldemar Cordeiro. Computer graphic, 1971

1–44 Waldemar Cordeiro and Giorgio Moscati. *Derivations from an Image*, 1969

standard line printer is used as the output device. The transformation is in fact based on the difference between each fragment's darkness value and its successor's. Thus, if a certain horizontal line of an image is given by the following sequence of darkness levels:

6 6 4 2 0 0 0 6 6 6 5 5 5 . . .

the derivative will be

0 2 2 2 0 0 6 0 0 1 0 0 . . .

Waldemar Cordeiro comments: 'This transformation creates another image in which the contour characteristics of the image are enhanced, and in which sudden changes in darkness give place to dark thin lines while soft changes in darkness are transformed into light bands. Second and higher order transformations are possible and the images have completely different structures.' Cordeiro and Moscati's mathematical transformations are trivially simple compared with, for example, the experiments that M. R. Schroeder of Bell Laboratories has done with a computer and microfilm plotter (1968); and the line printer is a crude output device for such imagery. However, Schroeder's graphics are pure technical demonstrations; Cordeiro's work is a start towards bringing back human emotions into the cold and cerebral world of the computer.

If you look at image 4 first, without having seen images 1 to 3, it is almost illegible. Even image 1 is obscure: the male and female heads in the left foreground are easy to read, but there are two standing figures on the right which are vague. There is an obvious link with Richard Hamilton's *Whitley Bay* paintings and Antonioni's *Blow-up*, which I have already referred to in the chapter on photography. It would be absurd to describe *Derivations from an Image* as a profound work of art; what is most interesting about it is the possibility it suggests of effecting a similar modulation on ciné film. It seems like so many stills from a film sequence, exploring, perhaps, an elusive human relationship without the need for actors in motion.[7]

Apart from the outdoor light spectacle by Vladimir Bonačić, all the actual output mentioned here has been in the category of computer

45 M. R. Schroeder. *Leprosy.*
This image – rather
unappealingly titled – was
made at Bell Laboratories with
a microfilm plotter and digital
computer from an original
photograph, as a purely
technical exercise. 'Contour
lines', connecting points of
equal brightness in the
original, were here modulated
in width

graphics. The motivation of the artists concerned has varied. It is
not part of this book's aim to give an exhaustive account of all the
work that has been done in graphics, sculpture, painting, music,
films, stage choreography, verse composition and other areas less
easy to categorize. Any reader interested in this field should refer
to the catalogue for the ICA 'Cybernetic Serendipity' exhibition in
1968, edited by Jasia Reichardt; to her little book on the computer
and art, and her collection of texts on the computer and cybernetics
in art; to the programme for the Computer Arts Society's inaugural
exhibition 'Event One' in March 1969; and to back numbers of the
CAS bulletin *Page* and of *bit international*, published by the very
enterprising and vigilant Gallery of Modern Art in Zagreb.[8]

Probably the best-known of all 'computer artists' is John H.
Whitney of the California Institute of Technology, who makes
abstract films where periodic phenomena are patterned visually in
time, as aural phenomena are patterned in music.

For anyone interested in the computer as a medium, hardly any
application of its capabilities is totally devoid of interest. But I have
tried to distinguish between those who use the computer to mimic
accepted graphic styles, and those who are confronting its

46 John Lifton. Projection modulator (early prototype), 1969

specific capabilities and constraints.[9] The actual physical presence of such work must be distinguished from its potential and implications. The computer is a medium which appears to oppose the advances of artists rather than encourage them; but I cannot believe that art will not spring from a technology that is so socially ubiquitous and also so germane to the processes of the human mind. At present very few artists have the insight to divine the implications of this new medium.

There is a general feeling that computer graphics have reached an impasse. Frieder Nake wrote in 1970 (*Page* 8) that 'the actual production in artistic computer graphics is repeating itself to a great extent. Really good ideas haven't shown up for quite a while.' It would be wrong to infer from this that the subject was dead for good.

Most of the artists discussed so far probably think of the computer more or less as a tool. There are a few others whose interest has been at the opposite end of the spectrum, in the computer as a potential rival – or at least partner – of the human mind. This interest has led them to delve into cybernetics, pattern recognition and artificial intelligence. W. Grey Walter's *The Living Brain* – with its

entertaining description of the mechanical tortoise, *Machina speculatrix*, that he built for the 1951 Festival of Britain — and the lively brainstorming speculations of Gordon Pask (1961) and Stafford Beer, have been influential in popularizing these disciplines, which depend in fact on difficult mathematics.[10] Pask has actually made a transducer to 'translate' music into colour effects, 'learning' new behaviours in collaboration with a performer; and also a mechanical allegory on the social condition called 'Colloquy of Mobiles' (see Reichardt, ed., 1968 & 1971 *b*).

One problem in assessing this area of work is that the reservoir of wisdom about such matters that artists can draw on is dangerously contaminated by 'bad' science — that is, science that is over-enthusiastic, over-speculative and contradictory. But if we accept that art is autonomous, grazing where it will, then art should be able to draw its nourishment from disreputable as well as reputable sources. It is impossible to predict whether the more extravagant speculations of certain artists and commentators will be looked back on in fifty years as genuinely clairvoyant or as a fad of the 1960s.

In this section I shall discuss only one or two representative artists working in this field.

John Lifton is a British architect who, like many members of his profession, has dropped out of architecture. At 'Cybernetic Serendipity' in 1968, he showed an electronically controlled light-system in which diffused visual images were projected against the whole interior of a geodesic dome, so as to involve the viewer 'rather than make him feel he was observing it'. At 'Event One' in 1969, he showed two systems as a stage in a large project. One of them responded to sound by distorting a flexible sheet of diffraction (rainbow-like) grating. Projectors were aimed at the surface, and the resulting image, projected on a wall or screen, moved as the surface distorted. A sister system was designed as a 'musical' unit where no information needed to be passed from composer to performer. A number of photocells, focused along a narrow beam, responded to light by passing signals to a computing device; this transformed the signals according to a 'logic' pre-set by the

composer. The performer only had to move in front of the 'eye' for music to be produced.

John Lifton's work falls into the category of what Robert Mallary (1969) has called 'transductive art' – electronic systems which 'transduce' one kind of energy to another. I shall discuss some artists who use electronics in Chapter Five. Here I merely wish to comment on Lifton's theoretical motivation for the work, and it is worth quoting from his programme note for 'Event One':

'The Modern Movement in architecture has perpetuated the classical tradition that man exists within a physically determinate environment. The basis of design may have shifted from beauty and proportion, via beauty and convenience to ergonomics and functional fitness, but the basic attitude is still the same. . . . We must start again from a fresh hypothesis: "The relationship between individual and environment is an information processing system." . . . If we are going to "design" for this situation, then we must deal with the system as a whole, consciously. . . . Architects generally have an interest in computers because of their potential as a design aid, but my own interest is in the direct participation of computers and electronic equipment in the environment. They offer ways of transferring information from expression in one medium to another and of thereby synthesizing separate sense perceptions into one experience. As an extension of this, it may not be long before our environment can be made to learn and respond intelligently to our needs and behaviour, and this will result in an interaction between man and environment in which they become fused into one extended system.'

I find such theorizing a little disquieting, since an 'intelligent' environment could be one consisting of bugging devices to monitor deviant behaviour, or even the 'electronic battlefield' which the US military is developing. Nothing could be further from Lifton's intentions, for he believes that through the information technologies the hierarchical and centralized structures of modern society will be replaced by a new consciousness comparable to primitive

74

animism, and that the free flow of information will destroy bourgeois ideals of privacy and class.

Lifton is now interested in using people's emotional reactions as control signals for electronic systems. In his current researches, he is attempting to use the Backster Effect, by which plants are held to respond electrically to the emotional state of organic systems around them:

'In *Interface 4*, a plant is growing in a transparent globe where it receives filtered air and the temperature and humidity can be controlled. Signals picked up from electrodes on the plant feed a small analogue computer which separates the response signal from the voltage variations due to the internal working of the plant. The amplified output voltages drive an electronic sound synthesizer and the sound output is reproduced in the same area. People's emotional response to the sound is perceived by the plant and the sound alters with this continuous feedback of information. As the system is still being developed I am not yet sure how sophisticated a response will be possible but the early results are encouraging.'

At this point I would have wished to describe 'Software', the ambitious exhibition organized by Jack Burnham at the Jewish Museum, New York, at the end of 1970. Unfortunately the exhibition was marred by acute technical problems, and I did not make the journey to see it. However, one piece stands out as a real advance in 'computer art': this was *Seek*, developed by Nicholas Negroponte and the Architecture Machine Group at Massachusetts Institute of Technology (MIT). It seems to me important in that it offers an ambiguous, in fact rather disquieting, statement about the relations between technology and the living. It is thus superior to Negroponte's book *The Architecture Machine* (1970), which is interesting but suffers in my opinion from two faults: a pious faith in the benefits of computing for mankind, and an ignorance about the difficulties of man-machine communication through natural language. The faith and the ignorance are not unrelated, and both characterize the 1960s more than the 1970s. But *Seek* is a more discreet and equivocal conception, and a considerable landmark.

75

47–48 Nicholas Negroponte. Two details of *Seek*, 1970 (see Appendix)

Seek is a sensing/effecting device – a device for finding things out and doing things – controlled by a small general-purpose computer. *Seek* deals with two-inch cubes which it can stack, align and sort by means of an electromagnet roaming overhead. These cubes form the built environment, cased in glass, for a small colony of gerbils. The gerbils are incessantly bumping into the cubes and disrupting constructions.

'The result is a substantial mismatch between the three-dimensional reality and the computed remembrances which reside in the memory of *Seek*'s computer. *Seek*'s role is to deal with these inconsistencies. In the process, *Seek* exhibits inklings of a responsive behaviour inasmuch as the actions of the gerbils are not predictable and the reactions of *Seek* purposefully correct or amplify gerbil-provoked dislocations. . . .

'Even in its triviality and simplicity, *Seek* metaphorically goes beyond the real-world situation, where machines cannot respond to the unpredictable nature of people (gerbils). Today machines are

77

poor at handling sudden changes in context in environment. This lack of adaptability is the problem *Seek* confronts in diminutive.

'If computers are to be our friends they must understand our metaphors. If they are to be responsive to changing, unpredictable, context-dependent human needs, they will need an artificial intelligence that can cope with complex contingencies in a sophisticated manner (drawing upon these metaphors) much as *Seek* deals with elementary uncertainties in a simple-minded fashion.'

Seek seems to me valid as art, and like much other art will bear interpretations which diverge from its original creator's primary intentions. Jack Burnham, the curator of the show, saw *Seek* as a model for the idea of making art (1970): 'Art could be rearranging blocks over and over again — just as sculpture is a matter of arranging forms infinitely. New aesthetics constantly force new arrangements in the same sense that the gerbils force the computer to model new possible environments.' It would be foolish to quarrel with him.

What has to be insisted on is the difference between artistic and scientific experimentation. Expressed as a scientific experiment or illustration, *Seek* would be rather offensive. Many books in recent years making facile and tendentious comparisons between animal and human behaviour have alerted us to the deficiencies of using science in this way (for instance, Robert Ardrey's *The Social Contract*). But *Seek* is more like a joke, metaphor, or poetic conceit than it is like a scientific experiment. I imagine that the spectator identifies now with the freedom of the gerbils to consume and excrete, scurry, court and squabble, now with the responsibilities of a lumbering bureaucracy to keep the environment orderly.

In fact I understand many of the gerbils at the actual exhibition fell ill and died.

Probably the most technically ambitious computer-based artefact yet made anywhere is the *Senster*, which was officially set in motion in 1971 at the Evoluon, a permanent industrial exhibition run by Philips, the giant electrical firm, at Eindhoven in Holland. The physical context is distracting, for the Evoluon is a paean to technology in the form of a flying saucer on legs, opened in 1966

78

49 Edward Ihnatowicz. *SAM (Sound-Activated Mobile)*, 1968. >
The artist's first electro-hydraulically operated environment-sensitive mobile. It 'listens' to the gallery-visitor by turning its head

and already something of a period piece. But Philips are to be congratulated on their intelligence and enterprise in commissioning this costly project.

Edward Ihnatowicz, a wartime refugee to Britain from Poland and now a British subject, studied at the Ruskin School of Drawing and Fine Arts at Oxford, and has worked as a sculptor, photographer, designer and furniture manufacturer. He exhibited S A M (*Sound Activated Mobile*) at 'Cybernetic Serendipity' in London in 1968, and was commissioned by Philips at the suggestion of the designer James Gardner. Realization of the *Senster* took more than two years. Ihnatowicz was helped by engineers from Mullard and Philips, and by the mechanical engineering department at University College, London, but his own self-taught command of scientific and technical detail is equalled by very few other artists.

About 15 feet long by 8 feet high, the *Senster* consists of six independent electro-hydraulic servo-systems based on the articulation of a lobster's claw, allowing six degrees of freedom. Crustaceans move by means of hinges, whereas most animals move by pivots, which are more difficult to reproduce in engineering. The *Senster* has a 'head' with four sensitive microphones which enable the

50 A lobster's claw which was the inspiration for Edward Ihnatowicz's *The Senster*, in the artist's hands

51 Edward Ihnatowicz. *The Senster*, 1971.
Installed at the Evoluon in Eindhoven. Note the two explanatory screens providing information for visitors, and the computer to the right

direction of a sound to be computed, and also a close-range radar device which detects movement. The whole is controlled by a digital computer, which tells the servo-system how to move in response to various combinations of sound and movement from visitors to the Evoluon. The acoustic 'head' is so designed as to give a vivid impression of an animal's eyes flicking from one object to another. The servo-systems can position the head within a second or two anywhere in a total space of more than 1000 cubic feet.

No attempt is made to conceal any of the mechanical or electronic components, or to give the *surface* of the machine a biomorphic ('lifelike') appearance.

Ihnatowicz decided that the most economic way of moving the claw would be by effecting constant acceleration and deceleration.

81

52 Edward Ihnatowicz working on *The Senster*

Halfway through any movement, an instantaneous reversal is made from a constant rate of acceleration to a constant rate of deceleration. An electronic predictor was designed to achieve this. Only after beginning to implement his idea did Ihnatowicz discover that measurements made on human beings, for the purpose of designing artificial limbs, had proved that human movement follows a similar principle.

The computer programme is not fixed but can be varied so as to generate different responses. At present, the head moves swiftly

towards any source of quiet motion, as though hunting for food. But if the motion becomes violent – say, a spectator tries to strike out at the claw – or if the amplitude of the sound rises – one person is monopolizing attention by shouting at it – the head will shy away as though frightened. Ihnatowicz hopes that new computer programmes will be developed so that the *Senster* will 'learn' new behaviours.

It will be easier to say how fully successful the *Senster* is when it has settled down with the half a million visitors who come to the Evoluon annually, and with the scientists who wish to experiment with it. In any case, the *Senster* is no monument to an artist's genius but a step towards new forms of creative collaboration on the highest level between scientists and artists. Ihnatowicz likes to work on projects where everyone involved is intellectually stretched.

One area that is likely to be artistically fruitful is the relationship between the computer and linguistics. There is a conversational computer programme called D O C T O R, written by Professor Joe Weizenbaum of M I T, which was not presented as 'art' but which is arguably one of the most effective works of computer art yet made. A typical fragment of conversation between a human patient and D O C T O R (via a typewriter terminal) is as follows:

Woman: Perhaps I could learn to get along with my mother.
Doctor: Tell me more about your family.
Woman: My mother takes care of me.
Doctor: Who else in your family takes care of you?
Woman: My father.
Doctor: Your father?
Woman: You are like my father in some ways.
Doctor: What resemblance do you see?
Woman: You are not very aggressive but I think you don't want me to notice that.
Doctor: What makes you think I am not very aggressive? . . .

Donald Michie comments (1968): 'Patients in the Massachusetts General Infirmary were allowed to converse with the program, after being warned that a computer, not a doctor, was at the other end

83

of the line. Sixty per cent of them subsequently rejected this information and insisted that they had been in communication with a flesh-and-blood doctor — "No machine could understand me that well" was a typical reaction.'

This is not an experiment in serious linguistics, since the plausibility of the programme is based on a trick of picking up key words and replying with stock phrases. The beauty of the experiment lies in the way it plays on the mechanization of our own language and human relationships, particularly as a comment on contemporary therapeutic procedures. Weizenbaum actually designed the programme to show how little content there was in non-directive psychiatry. As with *Seek*, there are disquieting implications about ways in which our lives are changing.

The computer and allied devices will certainly continue to be used in art. Works like *Seek* point forward in new directions, where the computer is treated as a medium and its social role is explored. But so far the constraints of working with the computer so dominate anything done with it that they actually appear to oppose the advances of the artist. It is as if the computer were some creature of great sexual attractiveness whose actual anatomy remains elusive, frigid and unexplored.

Laser Holography and Interference Patterning

Laser holography is the second major new medium that I will discuss. Its technical details, both theoretical and practical, are very complicated, but I shall mention only the broad principles, which are straightforward enough.

The original theoretical concepts of holography were stated in 1947 by Dennis Gabor. Full implementation was not possible till the invention of the laser in the early 1960s. The laser is a source of light all of whose waves are 'coherent', or in step.

To make a hologram, a laser beam is usually split into two beams by a semi-transparent mirror. (See illustration 53, 'Recording stage'.) One beam, the *signal beam*, is aimed at the object to be recorded, and light waves are reflected from it, so that a pattern of wavefronts flows from the object to a photographic plate. Another beam, the *reference beam*, is aimed straight at the plate, where it interacts with the signal beam. Thus the plate records interference patterns, the wavefronts of the two beams either augmenting each other to leave a bright spot on the plate (*constructive interference*) or cancelling out to leave a dark spot (*destructive interference*). This kind of interference does not happen with ordinary light, because ordinary light waves are unrelated to each other in *phase* (relative positions of wave-crests) and interfere chaotically, with no patterning effect. Ordinary photography can record only light intensity (the square of the amplitude); but a holographic plate or hologram records information about the wavefronts themselves: their phase and amplitude, in fact everything that the eye would intercept if it were located at the position of the plate.

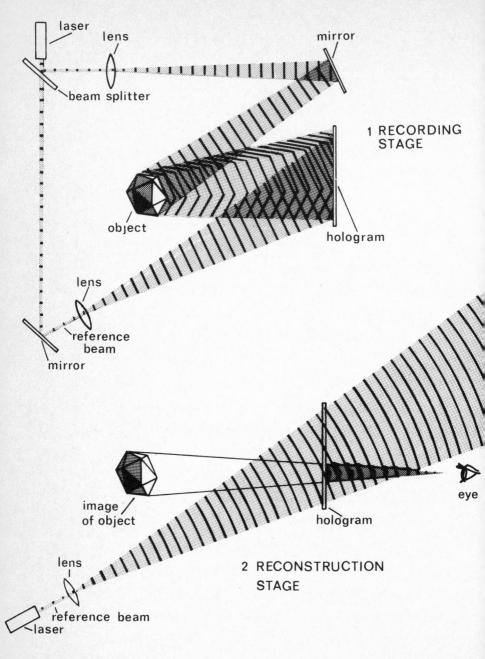

laser lens mirror

beam splitter

1 RECORDING STAGE

object

hologram

lens

reference beam

mirror

image of object

hologram

eye

2 RECONSTRUCTION STAGE

lens

reference beam

laser

53–54 Making and viewing a hologram

When the plate is viewed in ordinary light it is a haphazard jumble. The pattern is, in effect, encoded in the plate, and the 'code' can be broken only when the plate is illuminated with another laser beam (see illustration 54, 'Reconstruction stage'). The effect of holography is to 'freeze' an interference pattern until one chooses to reconstruct it; and another name for the technique is 'wavefront reconstruction'.

Some special properties of the hologram are as follows:

(1) The image formed is a mapping or collapsing of three dimensions on to two. If you move your head as you view the image under laser light, the normal parallax effect is apparent: that is, the relative positions of the objects appear to change. It is possible to move so as to see, for instance, a background object which is blocked by a foreground object. Holograms designed for didactic purposes often depict cut-glass objects, where glints of light appear and disappear as the viewer moves from side to side, or lenses, which cause objects behind them to enlarge or contract as the viewer moves forward and away.

55 A hologram viewed in ordinary light

(2) If a hologram is broken into pieces, each piece can reconstruct the entire original image, because every region of space of the object sends light to every region of space on the hologram. The smaller the fragments, the poorer the definition.

(3) Either the positive or the negative versions of a hologram will generate the identical 3-D image; there is no reversal of dark and light as in ordinary photography.

(4) With today's techniques, the images produced are speckled and coarse-grained. This does not show up in photographs of holograms, which are of course inadequate illustrations of the actual effect. The speckled effect is a peculiarity of laser light.

(5) Movement of an object during recording causes not the blurring of ordinary photography, but a loss of image brightness.

Explanations of all these properties, and several others, will be found in textbooks or in the sources that I list in the Notes to this book.[11]

After nearly ten years of development, laser holography still has no major applications in industry. Lasers are used for other purposes than holography, including military weapons; but apart from hole-drilling, holography is likely to be the most important use that will be found for the laser as far as industrial investment is concerned. A low-power type of laser is used in holography. This is safe but some precautions have to be taken to prevent the spectator looking directly into the light-source.

Holography will probably receive acceptance by industry during the mid-1970s for certain specialized technical applications (stress analysis and non-destructive testing). Longer-term potential applications include the photography of high-speed events; information processing and storage; chemical, seismographic and weather analysis; and 3-D movies, television, microscopy and X-rays.

It is the 3-D properties of holography that have attracted most attention, and there has been talk by artists of using large holographic projections in an architectural or theatrical context; so that, for instance, an illusory 3-D scene could be superimposed on a

real one. These are indeed interesting prospects, as is that of holo-graphic 3-D television and movies, which are bound to be developed sooner or later, probably in the USA or Japan. Unfortunately such speculations take people's fancy and they are then disappointed by the modesty of existing holographic techniques. In fact, if holography is as radically new and important a medium as I shall shortly argue, then it will develop not only in ways that we — or the entertainment industry — can predict, but also in new and unpredictable ways. The 3-D properties of holography are a by-product of far more fundamental principles.

A number of artists have worked with lasers, but only a handful have worked with laser holography. Among these are Jerry Pethick, Carl Frederik Reutersward and Bruce Nauman. The one whose work I know best (and who I think is most sensitive to the medium) is Margaret Benyon. I shall give a brief account of her work in holography before proceeding to argue the importance of holography as a medium.

Margaret Benyon, who had taught previously at Coventry and Leicester Colleges of Art, was appointed to a Painting Fellowship at Nottingham University in 1968. Like many painters of the 1960s, she was concerned with the modulation of painted surfaces through moiré patterns and similar effects. Some of her paintings are stereoscopic, painted to be viewed through green and red spectacles. However, during the three-year tenure of her Fellowship at Nottingham she devoted herself to research in holography, using a red helium-neon gas laser in the university's engineering department. She now has a Fellowship at Strathclyde University in Scotland. There is an interesting continuity between her painting and her holographic work, but the holographic work seems to me so much more powerful an enterprise that I shall confine my remarks to this.

Margaret Benyon's programme of research demands to be treated as art, not as some kind of science or technical demonstration. This does not imply that it is necessarily artists or art critics who will appreciate it most profoundly. She states that her chief interest is in 'phenomena that are peculiar to the holographic

56 The optical set-up involved in the making of the 'hot-air' hologram (next illustration). The laser is on the right

medium'; and this fits neatly with the approach I wish to make towards holography. Any dispute as to whether Benyon is an important artist is premature, since her work in a completely unexplored medium is defining its own criteria.

The first nineteenth-century photographic prints used conventional, homely subject-matter: for instance, the elder Niepce's 8-hour exposure of a courtyard in about 1826, and Daguerre's still-life with plaster-casts of about 1837. I am reminded of these by Benyon's 'still-lifes' of fruit and household objects. These give a magical effect of 3-D reality, but there are some subtleties. Why are the tomatoes and the bread so dark? The reason is that among the special properties of the hologram listed above is the fact that movement of an object during recording causes loss of image brightness, rather than the blurring which happens with ordinary photography. When moist fruit or fresh bread is holographed, the movement going on at the surface exceeds a threshold of about 0·0001 mm, and they appear dark or even black. If the bread is allowed to become stale, there is less surface movement and the image is brighter. A similar black void, hand-shaped, is left when a human hand − however steady to the naked eye − is included in a hologram. The first illustration also includes currents of hot air (rising from a cup) which would be invisible normally.

57 Margaret Benyon. Hot-air hologram, 1970–71 >

58 Margaret Benyon. Still-life hologram, 1970–71

Terms like 'surface', 'object', 'reality', 'tangible' and 'space' are hotly debated in the polemic of modern sculpture. Not surprisingly, Margaret Benyon takes the opportunity to comment on this debate both in the holograms themselves and in her verbal statements about them.[12]

The second illustration includes not only a black tomato but also a glass tumbler apparently hanging weightlessly in mid-air, and an orange floating through a bottle of milk. This is achieved by double exposure (one recalls the influential trick-photographs of the nineteenth century). In one of the two exposures, a tumbler and a wax orange were placed on a 'baffle', i.e. an object with a non-recording surface such as velvet.

I wrote above that the 3-D properties of holography are a by-product of far more important principles. The key principle seems to be that of interference patterning.

Holography is not a purely optical phenomenon. It is now necessary to categorize Benyon's work as 'optical holography', as opposed to acoustical holography, where a pure tone of sound instead of a laser beam is used to create a hologram.[13] It has also been suggested that bats use a holographic principle in pattern recognition: that when a bat emits an ultrasonic impulse of a certain frequency, at the same time the part of its brain which ordered the impulse to be emitted sends a 'copy' of this as a 'reference beam' to a second part of the brain, where the echo from the target is received and processed (Greguss, 1970).

To return to optical phenomena: a simpler example of interference patterning than laser holography is the moiré effect. Moiré patterns are described by Oster and Nishijima (1963) as simple analogues of complex mathematical phenomena. Large alterations in patterning can be produced by amplification from a very slight shift of phase or alignment. The rhythmic patterning of watered silk (*moiré antique*) is produced by the superimposition through pressure of slightly misaligned parallel weaves. Interference patterning has fascinated many painters and sculptors over the last twenty years, for instance Margaret Benyon herself in her early work and such well-known artists as Vasarely, Riley and Soto.[14]

59 Jésus-Raphaël Soto. *Monochrome Orange Picture* (detail), 1970

(It may be helpful to consider holography in its most general terms. It is the means whereby patterns or messages generated by events in a particular area of space and time interact to generate new patterns, which represent the way in which the separate events interrelate. These 'cross-correlations' are read out when we inject into them a reference wavelength, which has the property of imposing a kind of ordered set-structure. Several writers on the human nervous system have made analogies with holography.[15]

The full implications of interference patterning have still to be studied. But it seems likely that it is highly relevant to the process whereby ordering and organization emerge from the totality of physical interaction. Laser light, after all, is simply the result of causing the molecules of a gas or a crystal to behave in a more orderly way than usual.

⌐ Everyone assents nowadays to the importance and ubiquity of 'communication'. But one cannot begin, I think, to understand how messages are transmitted and patterns recognized, unless one accepts the importance of interference. Unfortunately the word in English has acquired overtones of destructiveness. The kind of language used to describe music, and the rhythmic aspects of

literature, may be more useful. If a new aesthetic is emerging today, part of it may be a finer sensitivity to interference patterning. We talk already of being on the same 'wavelength' as someone, of liking the 'tempo' of a metropolis, of absorbing the 'rhythms' of the countryside, and of getting 'good vibrations' from a situation or a person – as if the universe were an immense hologram of interfering wavefronts. Though these verbal usages are probably accurate, we lack both the perceptual tools to justify them and also the vocabulary for describing subtle interrelations.

The poets may help a little. Gerard Manley Hopkins's 'Pied Beauty' (1877) seems to celebrate – in an intuitive, unscientific way – the interference or interpenetration of wavefronts as a fundamental principle of life:

> Glory be to God for dappled things –
> For skies of couple-colour as a brindled cow;
> For rose-moles all in stipple upon trout that swim;
> Fresh-firecoal chestnut-falls; finches' wings;
> Landscape plotted and pieced – fold, fallow, and plough;
> And áll trádes, their gear and tackle and trim. . . .

A more complex example is T. S. Eliot's *Four Quartets*, with its often obscure but always insistent imagery of vibration and flickering, circulation and patterning. As much as anything else, *Four Quartets* is a poem about the experience of art, and of every-day perception, as complex physical interactions of events in time.[16]

An interesting speculation about holography is thrown out by C. H. Waddington in *Behind Appearance*, an extensive survey of the relations between painting and science in this century. Waddington is professor of animal genetics at Edinburgh University and an eminent all-rounder in the life sciences. He first discussed the relations between art and science in a book in 1941, and is a contributor to L. L. Whyte's collection *Aspects of Form* (1951).

Waddington's speculation concerns the tradition of 'inter-connectedness', which he traces in the analytical Cubists and later in the American Abstract Expressionists. A painting like Mark

95

Tobey's *Messengers* bears some resemblance to a hologram viewed under a microscope by ordinary (incoherent) light. Paintings like Tobey's, Jackson Pollock's and Dubuffet's often possess an 'all-over' quality which makes conventional ideas of 'composition' irrelevant. Waddington suggests that there may be an analogy between these paintings and the hologram, which seems chaotic and meaningless when we look at it in the wrong conditions, but which in fact contains more meaning than a conventional photographic image.

This is just a suggestive metaphor, which I shall not labour. Another scientist, David Bohm, has given holography a more important place in his thought.

David Bohm is professor of theoretical physics at Birkbeck College, London, and has made major scientific contributions in his field. I shall be coming back later in this book to his ideas on language, thought and reality. His views on holography have been expressed in a recent unpublished paper, 'Quantum theory as an indication of a new order in physics', and in a talk at the ICA in London in July 1971.

Bohm believes that the optical lens was a key factor in the development of modern scientific thought, since it brought into sharp relief the (approximate) one-to-one correspondence between 'points' in an object and 'points' in its image. This encouraged man's awareness of the various parts of the object, and of the relationships between these parts.

'In this way it furthered the tendency to think in terms of analysis and synthesis. Moreover, it made possible an enormous extension of this classical order of analysis and synthesis to objects that were too far away, too big, too small, or too rapidly moving to be thus ordered by means of unordered vision. As a result, scientists were encouraged to extrapolate their ideas, and to think that such an approach would be relevant and valid, no matter how far one went, in all possible conditions, contexts, and degrees of approximation.'

But now, according to Professor Bohm, 'relativity and quantum theory imply undivided wholeness, in which analysis into distinct

96

and well-defined parts is no longer relevant'. The laser hologram is a technique which can give an immediate perceptual insight into what can be meant by undivided wholeness in science, as the lens did for the notion of analysis of a system into parts. This is because there is no one-to-one relationship between parts of the illuminated 'object' (pattern of events in time) and parts of the image of this 'object' on the holographic plate. 'Rather, the interference pattern in each region . . . of the plate is relevant to the whole structure, and each region of the structure is relevant to the whole of the interference pattern on the plate.'

But the interference patterns are not *only* on the plate, whose function is merely to make a relatively permanent 'written record' of the interference pattern of the light that is present in each region of space. Bohm goes on to argue that holography suggests the germ of a new notion of physical order as a total order contained or *implicated* in each region of space and time. (A lens cannot produce an *exact* one-to-one correspondence, only an approximate correspondence, because of the wave properties of light; therefore the lens is more properly regarded as a kind of specialized or 'degenerate' hologram than as the opposite of the hologram.)

In principle, according to Bohm, the order implicated in each region of space extends over the whole universe and over the whole past, with implications for the whole future. This order is carried in an unbroken and undivided totality which Bohm calls the 'holomovement'; this we can sometimes abstract from — for instance, in talking of light, electrons, sound, etc. — but more generally 'all forms of the holomovement merge and are inseparable'. Bohm asks us to consider 'how on looking at a night sky, we are able to discern structures covering immense stretches of space and time, which are in some sense contained in the movements of light in the tiny space encompassed by the eye'.

This may sound far-fetched. But what one *sees* when one looks into a laser hologram is far-fetched. It should be added that by no means all physicists would agree with Bohm's ideas; and it is not clear quite how far he would press the argument about the

significance of holography. At the very least, however, the holo-gram provides an easily understood visual model of modern physics — and it has often been complained that since Einstein there have been no such visual models available to the layman, and that theoretical physics and cosmology have become arcane arts.

I find holography fascinating, and hope to have explained why to the reader. It is so young a medium that there has been hardly any social and economic history to recount — only the technical and aesthetic aspects. Therefore one can merely speculate.

Much more than the computer, holography is a medium which will swamp with its own mystery all attempts by artists at personal expression, for some time to come. Holography will over the years influence our art, our everyday perception, our language, reality itself — perhaps no less than did the discovery of the lens and optical perspective.

Kinetic Art in Transformation

I shall now shift the emphasis from media, which certain artists happen to have used, to artistic expression, where certain media happen to have been used. Media have already been described as techniques used for the transmission of information. Painting and sculpture I have already described as academic media, in that they have developed their own self-aware art-historical traditions. Utilitarian media I have defined as those which have social and industrial applications outside the domain of the fine arts. But these two categories do not exhaust the uses of technology in art.

Inventions and discoveries are developed not only for communications but for other types of technology too. Apart from communications, the largest class of technologies is the power technologies, used for the harnessing and direction of physical energy — most importantly for industrial and agricultural production, transport, and military armaments. Power technologies, like communication technologies or media, become social institutions and must be considered as such. Many key inventions — the cam, gearing, watermills, windmills, explosives, etc. — have been mainly associated with power technology. *155063*

In fact many of the power technologies have been used for aesthetic expression at some time or another, and thus become communication media of a special kind. An obvious example is the use of explosives to make fireworks. Otto Piene the kinetic artist has recently proposed that nuclear bombs should be exploded as fireworks in outer space (I am not sure how seriously he means the suggestion). But most modern kinetic art has used very simple techniques, and it is better considered as a complex of theories about expression than as a complex of media.

60–63 Ray Staakman. Kinetic piece, 1971

Contemporary art has in fact reached a point when artists are prepared to adopt *anything* as a medium; and there comes a point when we must begin to focus more on the coordinating power of artists (or the lack of it) than on the potentialities inherent in certain physical techniques.

Kinetic art — an art that concentrates on movement — is now regarded by many practising artists and critics as a stale idea. As often happens, the avant-garde is moving on to new things just at the time when there have been enough prestigious exhibitions in big cities for the general public to be rather enthusiastic about kinetic art. I believe that 'kineticism' has no theoretical basis that could be taken seriously today, and that it must already be treated historically. But it has been an important influence.

Kineticism was at least an attempt to develop a theory from which a new art might grow. As a fashion it has been partly superseded by 'technological art', but the latter has developed no coherent body of theory or principle. Ambitious exhibitions have been mounted — such as the Pepsi-Cola pavilion at the World's Fair in Osaka in 1970, and the 1971 'Art and Technology' show in Los Angeles — but the most interesting issues raised have been ones of project management, finance, and artist-industry relations, rather than of aesthetics. (The saga of the Pepsi-Cola pavilion has been recounted by Calvin Tomkins in the *New Yorker*. It was executed by the important New York organization Experiments in Art and Technology, led by the scientist Billy Klüver.)

The difficulty about 'movement' as an aesthetic principle is that in all or almost all visual art there is an important element of movement. This has been argued by Frank Popper in his comprehensive, if somewhat scholastic, study *Origins and Development of Kinetic Art*. As a spectator, one surveys an artefact from numerous angles and distances. Even when one's body and head are still, one scans the object with one's eyes over an appreciable period of time. Also, artists have used various techniques for centuries to suggest movement in static artefacts. The human psycho-optical system is highly susceptible to effects of 'virtual movement'. Popper and others have traced techniques of virtual movement in

painting back to Giacomo Balla, Monet, Redon, Seurat, Duchamp and many others, but these techniques had always been part of the repertory of the visual arts. 'Optical Art' has contributed to the now widespread awareness of the part that the human psycho-optical system plays in perception, and we now look with fresh appreciation at, say, the painted spinning-wheel in Velázquez's painting *Las hilanderas*.

Art that uses virtual rather than actual movement is sometimes, quite reasonably, classed as kinetic. But the label 'kinetic' is most frequently used to describe three-dimensional works in motion. An enormous amount of kinetic art has been made, and I shall not attempt to duplicate the studies by Popper (1968) and Guy Brett (1968), the perceptive comments in Hultén (1968), or the excellent historical chapter in Burnham (1968 *a*).

In fact it is doubtful whether kinetic art has ever recovered the liveliness and originality that it had before the Second World War. It has certainly become more pretentious. Marcel Duchamp, Lászlo Moholy-Nagy, Alexander Calder and Naum Gabo were the key figures in the development of kinetic art in the first half of this century; and much subsequent work has merely elaborated on their ideas. Perhaps the most important single work was Gabo's *Kinetic Sculpture (Standing Wave)*. He has recalled (1969) how this was made in the winter of 1919/20:

'It was the height of civil war, hunger, and disorder in Russia. To find any part of machinery or to do any kind of work in a recently nationalized factory in Moscow — most of which were idle and impenetrable — was next to impossible.'

He tells how he found an old factory bell and used its electro-magnet to make the metal rod vibrate. The *Sculpture* is at the Tate Gallery in London but is seldom exhibited, for fear of destroying it. Jack Burnham writes (1968) that it

'presents a virtual volume, a volume described by the speeding trajectories of an object. . . . The harmonic wave-form pattern which Gabo's construction creates is, in spirit, if not in physical principle, a visual echo of then recent theories of wave mechanics

102

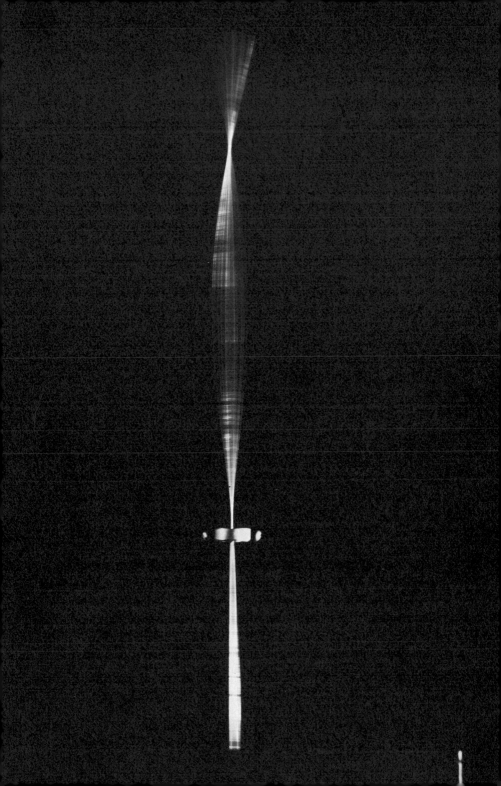

as the basis of matter. It announced on the macroscopic level — to the few capable of understanding the message — the essential immateriality of matter.'

Gabo abstained from following up this work (devoting himself to static constructions), on the grounds that electric motors were too crude for the kind of sculptural forms and movements that he envisaged. Certainly many kinetic artists since the Second World War have relied on techniques whose heaviness and crudeness Gabo would deplore. The device of the turntable, a rotating motor-driven surface embellished in some way or other, has dug its own particularly monotonous groove. Burnham calls kineticism 'the unrequited art', a medium with a 'long history of aesthetic, technical, and financial failure', but which none the less 'promises hope of open-ended discovery'.

Any aesthetic that singles out movement alone is bound to be unsatisfactory, just as is any aesthetic that singles out colour or space alone. Like many recent theories of art, kineticism has insisted too single-mindedly on but one aspect of our total experience.[17]

The question is further complicated by the revelation of modern physics that *everything* is in movement at a micro-level, and by the proposition that there are no objects in the universe, only interacting events and processes.

The idea of transformation in time is a more elementary and basic one than that of movement. The term 'transformation' or simply 'change' comprehends the idea of movement, but includes also events in time where something different from movement is perceived — for instance, the brightening or dimming of a light, or a change of colour. In fact, some of the most influential lines of thought that have developed over recent decades — in cybernetics, linguistics and ecology — have acquired a new vocabulary based on the rigorous and systematic notation of transformations; so this very basic concept is worth examining in relation to art.

Cybernetics concerns itself fundamentally with the transformations undergone by systems in time.[18] An exact notation and

mathematics exist for the description of different types of transformation, regardless of the physical characteristics of a particular system. In a 'determinate' system, each state the system is at will determine a unique state to which it will go next. In a non-determinate system, each state, instead of being transformed to a particular new state, may go to one of several possible states. Mathematical notations of probability may be used to describe cases where the selection of new states is made by some process or method that gives each possible state a constant probability of recurring.

Most of the best writers in that blurred and often obscurantist school called structuralism have recourse to the basic notion of transformation as a starting-point for sophisticated cross-disciplinary speculation. 'Were it not for the idea of transformation,' writes Jean Piaget (1971), 'structures would lose all explanatory import, since they would collapse into static forms'; for all structures can be seen as systems of transformation.

Machines are essentially systems for transforming inputs in a naked physical way. (Indeed there was at one time a tendency in cybernetic writing to extend the term 'machine' to cover, for instance, biological systems, but it seems to have met with a very understandable resistance.) Any everyday machine, from an electric toaster to an automobile, may be analysed logically as a self-regulating set of physical transitions on a set of operands or inputs. The interest of artists in machinery at a functional level — that is, going deeper into its workings than industrial designers and stylists have been accustomed to go — is a development which cannot but affect the general concept of art, turning attention towards dynamic structural relations at the expense of the surface 'feel' that is groped for by conventional visual aesthetics.

Much of the ideology of kineticism emerges from the faith in, and fascination with, technology and the machine which was expressed most uninhibitedly by the Italian Futurists, but which crops up through the twentieth century in various shapes. The romance of technology is compelling, and has been epitomized for the latest generation by the moon landings, as for earlier

105

generations by steam locomotion and aviation. But no one of any intelligence or sensitivity can have lived through any part of the twentieth century without learning to be critical about the social use of technology, which is becoming more and more clearly the kernel issue facing civilization.

D. H. Lawrence makes eloquent use of the imagery of machinery in his novels to symbolize the spiritual impoverishment of industrialized society. (The imagery can be traced back, if need be, to William Blake through Ruskin, Morris, Conrad and many others.) The basic qualities associated with machinery in Lawrence, and opposed to the organic or life principle, are (a) insensitive and inexorable repetition, as with Sir Clifford's motorized wheelchair in *Lady Chatterley's Lover* that runs amok and churns up some bluebells (a rather crude instance this), and (b) a reductiveness of human activities to specialized instrumentality or function. In *Women in Love* he identifies both these qualities of machinery with psychological obsessions (especially those of Gerald Crich), where a single mental function comes to dominate consciousness and reduce its sensitivity and freedom. This symbolism can illuminate our understanding of mechanical motion in modern art.

I shall consider two well-known kinetic artists who exemplify this obsessive quality in different ways, before going on to some less famous artists who also use machinery.

These two artists are Nicolas Schöffer and Jean Tinguely, who though very different in temperament exhibited together in 1965 at the Jewish Museum in New York.

Nicolas Schöffer, who was born in Hungary in 1912, and now lives in Paris, developed his theories of 'Spatiodynamisme' in 1948, and was one of the first artists to use electronic control systems. Schöffer must have been influenced by Moholy-Nagy's *Light-Space Modulator*, made between 1922 and 1930 (see illustration). This was some six feet high, and consisted of aluminium and chrome-plated surfaces driven by an electric motor and chain belts. It was spotlit, and in a dark room reflections were cast on walls and ceiling.

Schöffer has worked on a big physical scale: his electronically

106

65 Laszlo Moholy-Nagy. *Light-Space Modulator*, 1930 >

66 Nicolas
Schöffer.
*Spatiodynamic
25*, 1955

controlled light-tower at Liège is 52 metres high, and he is working on a much larger tower for Paris about the height of the Eiffel Tower. His kinetic spectacles use many flashing coloured lights, mirrors and shadows, and are always a great popular success at exhibitions.

I personally find them aesthetically conventional, to say the least. This might be a mere matter of taste, but Schöffer has accompanied his work with copious theorizing, and his utopian book *La Ville cybernétique* (1970) also contains illustrations of his architectural ideas — for instance, a huge 'Centre of Sexual Leisures' in the shape of a swollen breast. Though his cybernetic city is seriously presented as a desirable future possibility, it is reminiscent of those anti-utopias like Aldous Huxley's *Brave New World*, and is one of the most unpleasant exercises in futurology that I know of — mirroring and romanticizing the fragmentation and de-humanization of modern industrial societies, rather than attempting to clarify or correct these tendencies. On art, for instance, Schöffer writes:

'Surrounded by audiovisual programmes (olfactory, tactile) that will bathe him in a superaesthetic atmosphere, the consumer will be able to recompose and reprogramme the various elements of this aesthetic bath according to his own needs.'

A further proposal is for 'static centres of leisure', where people will be able to shut off entirely from the outside world in a constant controlled environment:

'Certain categories of intellectual or physical workers will be *obliged* to pass by these static centres before returning to their active life which becomes more and more dense and accelerated.' (My translation, my italics.)

If one suggests to one's friends that Schöffer is *not* the best that kinetic art has to offer, one is sometimes accused of being a kill-joy. But art is not merely entertainment. There is nothing wrong — far from it — in the playfulness of children and their love of intricate spectacle and novel sensations, but art should provide a more complete and organized experience. We come to art as whole

67 Nicolas Schöffer. *Microtone 9,* 1963

human beings in search of meanings, not as jaded 'consumers' in need of a forcible 'aesthetic bath'.

Jean Tinguely, who was born in Switzerland in 1925, is very aware of the disquieting aspects of machinery. He seems both fascinated and repelled by machines. Tinguely was one of the first artists (another was Gustav Metzger) to theorize, in about 1960, about 'auto-destructive art' and thus facilitate the withering-away of the consumable artefact – a withering which has been such a marked feature of avant-garde art over the last ten years. In 1962, in an American desert, he ritually detonated a heap of junk called *Study No. 2 for an End of the World*.

Tinguely is refreshingly unpompous and witty. For instance, his *Rotozaza* (1967) is a social parable: an elaborate machine, making a virtue out of bad engineering like most of his work, whose output (rubber balls) has to be fed back into it by the spectators.

Tinguely is an attractive artist, but, far from escaping the obsessive, nightmarish quality that marks so much machine art, he actually relishes the nightmare. It is rather similar to nineteenth-century nightmares about the dominance of machines, and his actual machinery owes little to the twentieth century. My own admiration of Tinguely has varied with the extent of my disquietude about modern technology.

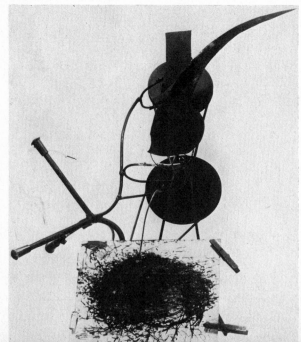

68 Jean Tinguely.
*Painting Machine
or Metamatic*,
1961

110

69 Jean Dupuy. *Fewafuel*, 1970–71

A mutation of Tinguely's useless machines is *Fewafuel* by Jean Dupuy, a French-born artist who lives in New York. It was perhaps one of the most conceptually interesting contributions to the Los Angeles 'Art and Technology' show in 1971. *Fewafuel* is simply a diesel engine, adapted in collaboration with the Cummins Engine Company of Columbus, Ohio. As its name implies, the four 'elements' Fire, Earth, Water and Air are made visible as sources of energy or as wastes, thus indicating the basis in nature of the engine's system.

An inverted bell jar collects carbon debris (Earth); a window shows the fuel in combustion (Fire); Water is seen gushing through a section of glass piping, and Air is the fan system for cooling. The public can participate by operating a throttle from a driver's seat. A fifth element, Sound, is enacted and is said to be deafening. In fact, the exhibiting of *Fewafuel* in a part of the United States where the internal combustion engine is coming to be execrated for its environmental effects was tactless, and I gather some visitors objected to it strongly.

70–71 (Overleaf) Jean Tinguely.
Study No. 2 for an End of the World, 1962

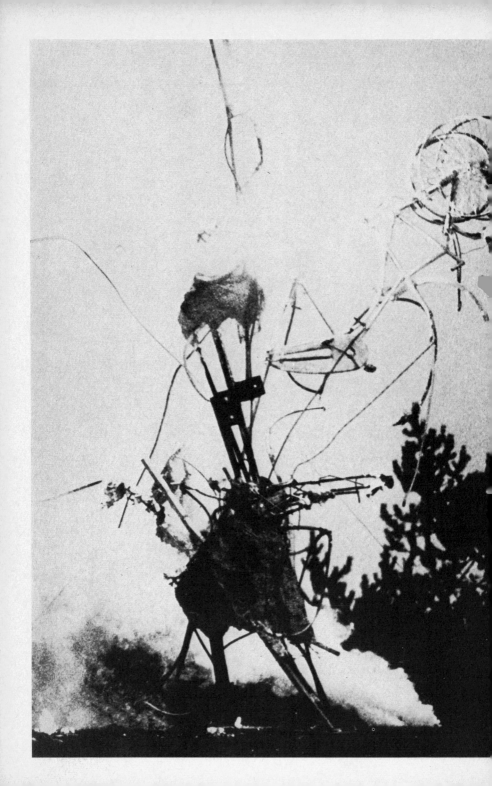

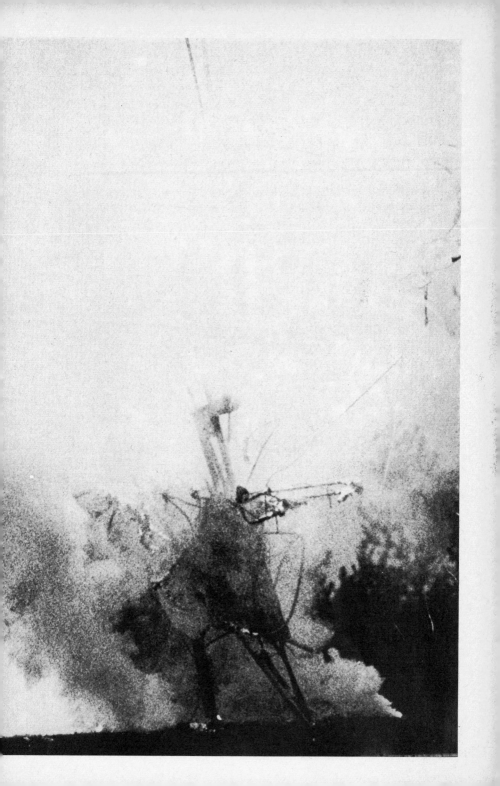

Jean Dupuy and an engineer, Ralph Martel, won first prize in a 1968 competition in New York with *Heart Beats Dust*, a glass-faced cube in which dust, strongly illuminated, is activated by the rhythm of heart beats.

A development of the idea of the three-dimensional work in motion has been the artefact whose own states are transformed in response to inputs from the spectator (and sometimes to random inputs). This extra element of participation or 'feedback' breaks down the repetitiveness of purely cyclical machines, and gives the spectator (so it is contended) a more active function in the artistic process.

If a machine is to perform in this way, it must have some kind of sensing device or control to pick up energy inputs from the environment. The throttle in Jean Dupuy's *Fewafuel* that I have just mentioned, and various pedals used to activate Tinguely's machines, are mechanical versions of this principle. In electronic systems, microphones and photocells to pick up sound and light respectively are the most favoured sensing devices, since standard electronic equipment already exists. (John Lifton's 'transductive' systems have already been discussed in Chapter Three, and there are numerous other artists who are working in similar media.) There are many other possibilities for receiving inputs: for instance, the Korean artist Nam June Paik asks the gallery visitor to pass a large magnet over a colour TV screen and observe the resulting visual interference.

One artist seems to me to stand out in the whole field of kinetic and electronic art, using spectator participation with subtle effect. This is Tsai. I shall describe his work in some detail.

Tsai Wen-ying has followed an ambitious and coherent path of work without concern for the fleeting antics and grimaces of the art community. A glance at his career will indicate that in education and experience he is out of the ordinary.

Tsai was born in Amoy, China, in 1928 and had his first lesson in Chinese brushwork at the age of eight. In 1950 he came to the United States as a student of mechanical engineering at the University of Michigan, while pursuing his art studies. He was later

in charge of numerous major engineering and architectural projects. In 1963 he was awarded a John Hay Whitney Opportunity Fellowship, and he resigned from his engineering career to devote himself totally to art, working with optical effects, radiant paints, ultra-violet light, etc. In 1965 he exhibited a 'multi-kinetic wall', and in 1966 he developed the techniques of 'cybernetic sculpture' which he has been working on ever since. He spent two years as a Fellow at Gyorgy Kepes's Center for Advanced Visual Studies, MIT, and is now living in Paris.

An exhibition by Tsai is presented as a total environment to which each piece contributes. The overall effect is from bluish high-frequency strobes, which create a strange and other-worldly visual effect. Each piece is different but they have certain design features in common, like different species of the same genus.

Each consists of a number of stainless-steel rods set on a platform vibrating at a constant and unvarying rate of 20 to 30 cycles per second. But the flashing of the strobe makes the eye see the rods as oscillating asymmetrically. Each flash lasts for a few millionths of a second only, and the intervals between the flashes are of variable duration. When the rate of the flashes equals the rate of the vibrations of the rods – we may call this the 'synchronous rate' – the motion of the rods appears stationary in the shape of a harmonic curve. When the rate of the strobe-flashes is altered to slightly slower or faster than the rate of vibration, then the rods appear to be slowly undulating. The greater the deviation between the rate of the flashes and the constant harmonic motion of the rods, the more rapidly the rods appear to move. There is thus a range from relaxed undulation to excited palpitating. The direction of the apparent spiralling (clockwise or counter-clockwise) depends on whether the rate of the strobe-flashing is above or below the synchronous rate.

It should be added here that whereas most kinetic art and exhibitions thereof are notorious with the public and with museum curators for their mechanical unreliability, Tsai designs his exhibitions for round-the-clock non-stop performance, using special motors and steels to achieve this.

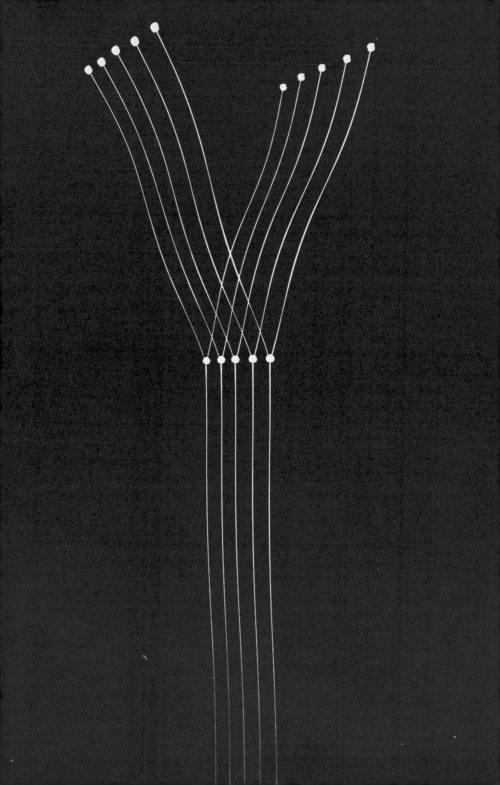

In some of the pieces, the rods are capped with nipples or with steel plates. When each of the plates is seen as two plates merging into each other's space, it makes a visual reality out of a physical impossibility. (This phenomenon occurs at a little over double the synchronous rate.) Other pieces have rods capped with optical diffraction gratings, and these show up like fluttering iridescent blooms. Still others are topped by large hoops, or ramify into one or two levels of branches.

One or two of the pieces respond to the physical proximity of the spectator by means of a sensing device. But the majority respond to sound by means of microphones which cause switches to vary the frequency of the strobe-flashes. Clap your hands, or raise your voice above a whisper, and one whole structure will shimmer as if frozen for a few moments to a more solid substance, then shudder back to normal until discomposed again by your exclamations of awe. Others, with the switching 'logic' reversed, get more excited the louder the ambient noise.

It is worth noting that Tsai's techniques taken separately are not particularly revolutionary. The principle of 'virtual volume' was known in the nineteenth century, and I have already mentioned Gabo's 1920 *Kinetic Construction*, which consists of a single vibrating rod. Both strobe lighting and the feedback principle were used before Tsai; although no one before Tsai had integrated these particular techniques. But a more important point is that his techniques have been put behind him, and his creations look effortless and spontaneous, as if the artist's coordination of his technical resources were indissoluble from the coordination of his own instincts and intelligence. This power to coordinate and organize is one traditionally associated with the artist; where it is lacking, the result seems not art but a contrivance — willed by the mind, with no concurrence of the nerves and instinct. Faced by such work, we find ourselves commenting on the maker's technical skill or lack of it. Faced by a Tsai exhibition, one recovers a primitive wonder at his evocation of the organic.

Tsai's 'objects' are self-organizing systems, like the sea-anemones or water plants that they evoke, in that they maintain, by

< 72 Tsai Wen-ying. Cybernetic sculpture, 1971

73 Tsai Wen-ying. Cybernetic sculpture, 1967—68

74 Tsai Wen-ying.
Cybernetic sculpture, 1967–68

the control of certain variables, a stability or equilibrium necessary to their survival. They are of course less complex than the simplest natural organisms in the transformations of energy resources of which they are capable. They might be described as abstractions or homomorphisms of organic life. Many biologists have stressed the importance of a dynamic and therefore fluctuating equilibrium between opposing tendencies.

Tsai's basic technique of vibrating rods (like Gabo's) presents the paradox that the vitalizing current on which the whole artefact is dependent for energy is also a disturbing force which stirs the rods from static equilibrium. The ecology of these 'organisms' demands not only electric power but also the presence in their environment of a different species – the human participant, with his curious (and rather lazy) optical system. The work of Tsai is challenging to the photographer, who is obliged to mimic the human psycho-optical system's real-time system with a mechanical device that behaves differently. Tsai's strobing technique plays on our tendency to see constant forms and creates the effect of sinuosity peculiar to his work: an irregular, asymmetric oscillation giving a taste of the interferences and complexities of organic life.

Between artefact and observer – or environment and participant – is set up a kind of mutual dependence or symbiosis. In the structures that incorporate reaction to spectators' behaviour, an additional factor of dependence is introduced. The sounds of humans which the microphone picks up are in a way like the electric current: a force that disturbs the artefact's mechanical stability but is also an essential source of its artistic life or potency: a kind of creative interference.

In fact the symbiotic relationship between observer and artefact is true of all art. Tsai's work functions as a metaphor for art in general. It is a paradigm of the process whereby art depends on constant refreshment or re-creation by its own environment. With the current switched off, or without the participation of spectators, Tsai's works are as drained of life as sea-anemones stranded in an empty pool, or a cine-film projected into sunlight.

75 Tsai Wen-ying. Cybernetic sculpture, 1970 >

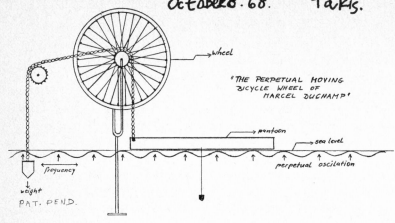

Hommage à Marcel Duchamp
Octobre 8. 68. Takis.

> wheel

"THE PERPETUAL MOVING BICYCLE WHEEL OF MARCEL DUCHAMP"

> pontoon
> sea level

> frequency

perpetual oscilation

↓ weight
PAT. PEND.

76 Takis. *The Perpetual Moving Bicycle Wheel of Marcel Duchamp*, 1968

His works are more like examples of biological symbiosis than they are like tangible objects; and, if this is true, there are important implications for our whole notion of the nature of artefacts. We know from modern physics that there are no longer such things as objects, only events. Dr Johnson is said to have kicked a stone once to refute Bishop Berkeley's contention that objects only existed in the human consciousness. It would not be so reassuring to kick Tsai's work, any more than to kick a cinema screen on which a film is projected.

Tsai manipulates a few sources of energy with extreme economy – electric power, human sounds and so forth – as a model for all the infinitely various resources on whose coordination the equilibrium of life and the environment depends.

There is a kind of alternative kinetic tradition which depends less on motors and machinery. The best-known kinetic artist of all, Alexander Calder, made motorized mobiles during the early 1930s, but since then has concentrated on mobiles activated by the air or by touch. Duchamp's bicycle wheel (1913) stood inverted on a kitchen stool, to be rotated manually.

More recently, Takis's work uses the invisible energy of magnetism, and his *Hommage à Marcel Duchamp* (1968) uses the waves of the sea to turn a bicycle wheel. Otto Piene – a German artist who founded the Group Zero with Heinz Mack in the late 1950s – has used many different media but his use of flags, kites and streamers in city spaces is particularly successful. Jésus-Raphaël Soto makes 'penetrables' which the spectator enters; these are well described by Jean Clay (1969) as extending the interest of the Cubists and Futurists in the fusion of objects and their environment.

Guy Brett's book on kinetic art (1968) is more interested in this non-mechanical tradition than in technology. Artists like Lygia Clark, Helio Oiticica and John Dugger – whose work depends on being physically manipulated by one's body, sometimes in collaboration with other people – are reverting to a kind of primitivism, in reaction against the intellectualization of art.

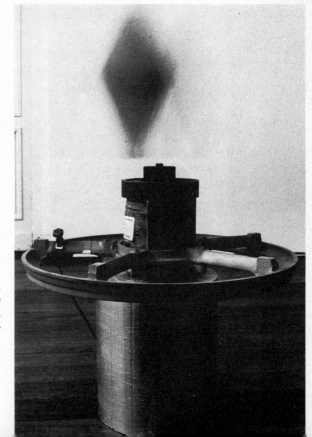

77 Takis.
Homage to
Vaslav Nijinsky,
1964

78 Otto Piene. Helium-inflated polyethylene tubing (transparent), 1970

Lygia Clark, whose work lures one into an erotic game, represents one line of kineticism — a reaction against technology, a reversion to the human body as a fount of true experience. When she invites two people to manipulate large shaped sheets of transparent plastic — one lying on the ground, the other standing over his/her body — one can certainly argue that she is using the human body as a mechanical medium: the two participants, together with the plastic, become a 'system' which can undergo a limited set of transformations in time and space, according to the constraints of its coupling. But to labour this analysis would be inappropriate, since she is interested in psychic exchanges rather than in topology.

Some artists — preferring to avoid machinery, computers and electronic devices, yet wishing to make art that undergoes controllable transformations in time — go back to the automatic transformation processes inherent in nature. Gustav Metzger writes of 'material-transforming art', and was himself one of the first artists

to experiment with cholesteric liquid crystals, during the late 1960s. These rather freakish chemicals respond to specific temperature-changes in the environment — in Metzger's work, to the heat of light projected through them — with a gradient of iridescent colour changes, due to multi-layered optical interferences at a molecular level. Why use complicated machines, it may be asked, when nature's automatism is cheaper and more reliable? This applies not merely to exotic materials like cholesteric liquid crystals but to more homely things like water, ice and air — media which have already been extensively used.

Among the artists I mean are Gyula Kosice and David Medalla. Medalla was editor of a remarkably lively magazine, *Signals*, in London during the mid-1960s and is best known for his bubble-machines. I shall discuss in the next chapter two artists who use 'natural systems' very successfully, Hans Haacke and Alan Sonfist. Though they have characteristics in common (which is why they are discussed here under the heading of art and ecology), they are very different artists, as I shall show.

Science and technology are for neither Haacke nor Sonfist a preoccupation or obsession, but simply important factors in the environment they live in. Their sober intelligence contrasts with the dramatic attitudes struck by artists like Schöffer and Tinguely.

79 Lygia Clark.
Mandala for Group, 1969

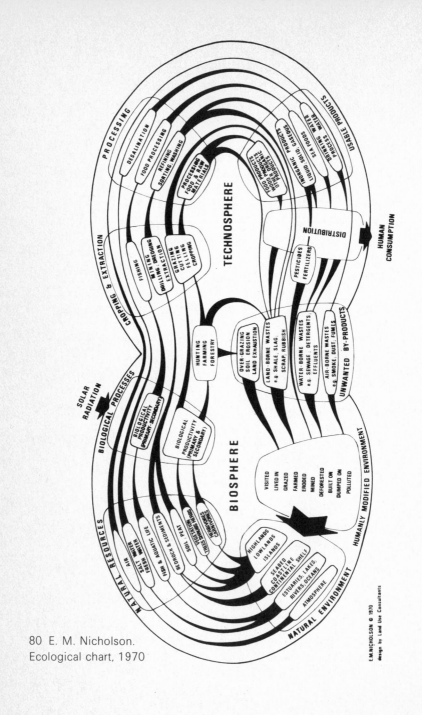

80 E. M. Nicholson.
Ecological chart, 1970

Art and Ecology

Only a few years ago, it would have been necessary to explain what ecology was about before mentioning it in a book intended for the general reader. Now, however, the principles and aims of ecology are fairly widely known, following a spurt of publicity and lobbying since about 1968.

Until fairly recently, biology gave most of its attention to the study of individual organisms. Ecology is to do with life-processes, energy transformations, the utilization of resources and the satisfaction of needs at a superorganismic level. Though traditionally regarded as a sub-set of biology, it may legitimately be regarded as a generalized approach which takes in the whole question of relationships between communities of plants, animals and inanimate nature. In considering human ecology, we cannot ignore the 'technosphere' that man has imposed on nature – for instance, inventions like the motor-car, the aeroplane, the computer – nor can we ignore other social and cultural institutions. Ecology is thus related to the social sciences and also to the humanities.

In the last chapter I suggested that the sculpture of Tsai works rather like biological symbiosis, and that this kind of art is a metaphor for a general fact about art. The model of symbiosis can be elaborated a little. Where human artefacts are concerned, we are dealing with entities that are not self-sufficient but depend on continuous refreshment from *their* environment, including ourselves. Maurice Merleau-Ponty writes (1945):

'Our senses interrogate things and they reply to our senses. . . . The relations between things or between the aspects of things

being always mediated by our bodies, the whole of nature is the *mise en scène* of our own life or our interlocutor in a sort of dialogue. That is why in the last analysis we cannot conceive of anything which is not perceived or perceptible. . . . All perception is a communication or a communion, the taking up or the completion by us of an alien intention, or inversely the external realization of our perceptual powers, and as it were a coupling of our bodies with things.'

Art, like life, is a manifestation of high organization. There is an old analogy between works of art and organisms — originating in Plato and Aristotle, refined by Coleridge. Ecologically speaking, the 'coupling' of one's body with an artefact is a kind of symbiotic relationship, a cyclation of mutual sustenance. Men need art for the fulfilment of those needs which differentiate us from brutes or automata. An artefact requires not merely the presence of human beings, with our unique psycho-physiological apparatus, if it is to continue as it was 'programmed' to by the artist. (Otherwise it is no more use than 'a sun-dial in a grave', in the phrase of Donne.) It also requires, if it is to thrive properly, an environment which we call a 'culture', where the connectivity among people and artefacts is immensely rich.

Symbiosis, like all ecological relationships, consists of processes and transformations in time. The introduction of a kinetic element into the visual arts of this century, both through kinetic art so-called and through such media as cinema and television, has merely provided a new explicit emphasis. Frank Popper is right to stress the element of time in all art, though this is more traditional to music and literature than to the visual arts. He quotes a beautiful sentence by Sartre: 'The literary object is a strange kind of top, which only exists in motion.' Eliot writes in *Four Quartets*:

> *Only by the form, the pattern,*
> *Can words or music reach*
> *The stillness, as a Chinese jar still*
> *Moves perpetually in its stillness.*

Certain works of art like Tsai's have the property of responding in a literal, physical sense to the presence of the beholder. Rather than generating an Academy of kineticism, they should make us look anew at art and at media of communication. To quote Eliot again:

The natural wakeful life of our Ego is a perceiving.

The symbiotic model for art that I have outlined does not by any means exhaust the implications of ecology for art.

Hans Haacke is an artist who has been much in the limelight recently for reasons of art politics. Some excellent articles about his work have appeared in art magazines, by Jack Burnham (1968*b* and 1969), Bitite Vinklers (1969), John Noel Chandler (1969) and Jean Clay (1970). Since it contains a heavy conceptual element (especially his more recent work) it is easily made known to the public through international journals and similar media, whereas the work of an artist like Tsai depends to a great extent on the physical experiencing of it. I have physically experienced little of Haacke's work myself, and am largely dependent on published sources and discussion with the artist.

Haacke believes that art must range wide:

'The artist's business requires his involvement in practically everything. . . . It would be bypassing the issue to say that the artist's business is how to work with this and that material and manipulate the findings of perceptual psychology, and that the rest should be left to other professions. . . . The total scope of information he receives day after day is of concern.'

He claims no detailed scientific expertise. His interest in science is more a general perception of dynamism and change as paradoxically the chief invariant in the universe.

The development of his work, since his early prints, paintings and wall reliefs, falls roughly into three stages. The first stage consists of natural or technological systems – Haacke does not make much distinction between the two – that are constantly affected by changes in the environment. Many of these pieces use water as a

material, exploring its very specific properties. *Weathercube* (1965), for instance, contains water which condenses on to the container's walls, creating ever-changing patterns. He has also grown grass in exhibition conditions, and used air currents to activate fabrics.

In a second phase — following the principle of Duchamp's 'readymades', by which anything is art if it is signed, or nominated as art, by the artist — Haacke began to explore larger environmental processes, physical, biological and also social. *Chickens Hatching* (1969) consists simply of fertilized eggs in an incubator. On another occasion in 1969 he gave a demonstration of wind-patterns in snow on a studio roof in New York. He has also exhibited (1969) the 'Newborn Identification Document' of his baby boy Carl, issued by a hospital — including the baby's foot-prints and his mother's fingerprints; and on another occasion a New York meteorological chart.

The third phase of Haacke's work is a move towards actually *disturbing* ecological, social and political equilibria. This has taken Haacke into courageous and dramatic clashes with institutions, such as the famous 'Haacke/Guggenheim affair' in the spring of 1971 when Haacke's one-man show at the Guggenheim Museum was cancelled by the director, Thomas Messer, because some photographic exhibits depicting real estate in New York, together with information about the landlords abstracted from public records, were alleged to amount to an attack on certain specific property-owners. Haacke denied the allegation hotly, and turned the whole incident brilliantly to his own advantage. Jack Burnham considers the affair a major turning-point in art politics and wrote about it in *Artforum* (June 1971).[19]

The ecology movement has been very successful in many countries, particularly America, Britain and Japan, and has generated a rhetoric of its own, associated with such emotive themes as pollution, over-population, survival and doom. Many artists have drawn on this rhetoric with an enthusiasm that is a credit to their social conscience or sense of timing, but does not always make for coherent expression. The ecological references must in fact often be taken with a pinch of salt. One work which

81 Hans Haacke. *Chickens Hatching*, 1969

82 Hans Haacke. *Weathercube*, 1963–65

83 Newton Harrison. *Fishtanks — Survival Piece*, 1971

deserves serious consideration, despite a questionable conceptual basis, is Newton Harrison's *Survival Piece 3: Portable Fish Farm*. This was exhibited at the Hayward Gallery in London in the autumn of 1971 in a group show with ten other Los Angeles artists. It will be remembered more as a news story than as a work of art, for Harrison drew protests from the Royal Society for the Prevention of Cruelty to Animals, and others, on account of his proposal to electrocute two dozen catfish in public. His defence of the electrocution was that it was only part of a larger metaphor. The farm consisted of six sea-water tanks containing catfish, oysters, shrimps and lobsters. The catfish were actually bred in a special spawning container, as far as was practicable in an exhibition that lasted only five weeks. Such fish-farms may one day, it was speculated, become a practical necessity if pollution of the sea continues. Harrison also argued that electrocution was the most humane way of killing fish.

In my view the protesters had an important point, for Harrison was proposing to take life *in a symbolic rite*, however well-intentioned. He seemed naïvely unaware of the very powerful literary symbolism of electrocution, which surely evokes judicial execution, whether just or unjust. The controversy was also to some extent a matter of cultural mismatch, as the English public is known to be incurably sentimental about the welfare of animals, and the American public more inured to violence.

132

The key point I want to make is that Harrison called his work a 'cycle of production and consumption', since the catfish were to be killed and then eaten at a 'feast'. In the ecological sense, however, there was no cycle exhibited, except I suppose in the local exchange of energies occurring within the ecosystem of each of the six tanks. The *Farm* required an elaborate support system of water-heaters, agitators, syphons, etc., powered by electric current which presumably was generated at one of the big power-stations in South London that belch smoke into the air. Harrison failed to recognize that his consumption of power was polluting the air of London and using up fossil-fuels.

To take the cycle further on: the guests who consumed the catfish — a rather élite group called the Contemporary Arts Society — had to transform the energy in some way. I am not insisting that Harrison should actually have made a collection of the guests' excrement and recycled it into the system. But there was no hint in the presentation of his artefact that he was interested in the central idea of ecology, which is that of the continuity and inter-dependence of processes.

Harrison wrote in the catalogue: 'I want to know how I will survive — how we'll all survive.' This rhetoric of survival is now a familiar part of the American cultural scene, reflecting perhaps the economic jungle in which any American artist — one of the few

84 Newton Harrison. *Survival Piece 3: Portable Fish Farm*, 1971

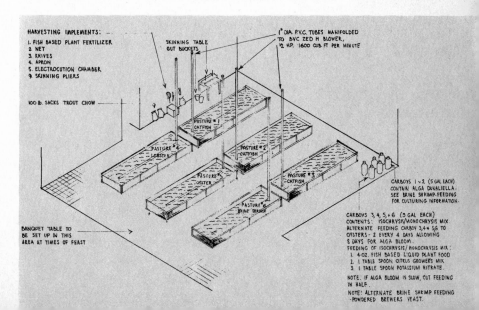

HARVESTING IMPLEMENTS:
1. FISH BASED PLANT FERTILIZER
2. NET
3. KNIVES
4. APRON
5. ELECTROCUTION CHAMBER
9. SKINNING PLIERS

SKINNING TABLE
GUT BUCKETS

1" DIA. P.V.C. TUBES MANIFOLDED
TO BVC ZED H BLOWER,
½ H.P. 1600 CUB.FT PER MINUTE

100 lb. SACKS TROUT CHOW

PASTURE #1 CATFISH

PASTURE #4 LOBSTER

PASTURE #2 CATFISH

PASTURE #5 OYSTER

PASTURE #3 CATFISH

PASTURE #6 BRINE SHRIMP

BANQUET TABLE TO BE SET UP IN THIS AREA AT TIMES OF FEAST

CARBOYS 1 × 2 (5 GAL EACH) CONTAIN ALGA DUNALIELLA. SEE BRINE SHRIMP-FEEDING FOR CULTURING INFORMATION.

CARBOYS 3, 4, 5, + 6 (5 GAL EACH) CONTENTS: ISOCHRYSIS/MONOCHRYSIS MIX. ALTERNATE FEEDING CARBOY 3,4+ 5/6 TO OYSTERS — 2 EVERY 4 DAYS ALLOWING 8 DAYS FOR ALGA BLOOM. FEEDING OF ISOCHRYSIS/MONOCHRYSIS MIX:
1. 4 OZ. FISH BASED LIQUID PLANT FOOD
2. 1 TABLE SPOON CITRUS GROWERS MIX
3. 1 TABLE SPOON POTASSIUM NITRATE.
NOTE: IF ALGA BLOOM IS SLOW, CUT FEEDING IN HALF.
NOTE: ALTERNATE BRINE SHRIMP FEEDING -POWDERED BREWERS YEAST.

remaining freelances in an institutionalized society — has to compete. Artists must be more lucid than Harrison if they are to be taken seriously when they imply that their work is actually promoting the survival of the human race. None the less I am entirely on Harrison's side when he says:

'Art has to change. Its whole ground must be redefined. It is sterile; it is a closed system; it is stiflingly cross-referential and its yield per quantum of effort expended is pitifully low.'

We have so far considered Haacke, whose work has a great deal to do with ecology but who as far as I know does not borrow the rhetoric of the ecology movement, and Newton Harrison, who borrows the rhetoric in a high-principled but unsatisfactory way. Alan Sonfist aligns himself with the younger and more radical wing of the American ecology movement, which is out to change the whole value-system underlying over-production, over-consumption and industrial colonialism. He writes:

'My art presents nature. I isolate certain aspects of nature to gain emphasis, to make clear its power to affect us, to give the viewer an awareness that can be translated into a total unravelling of the cosmos.'

The call 'back to nature' can easily become a romantic evasion of more painful problems of society and politics. It is certainly true that when a personified Nature is invoked to teach us lessons about human society we should be on our guard. Simone de Beauvoir, in a stinging attack on right-wing ideologies (1955), remarks that: 'Nature is easy-going; she says the words that are dictated to her.' Mary Douglas the social anthropologist (1970) suggests that Nature is a cultural construct and chiefly a method of social control; other universal ones are time, money and God.

While heeding these caveats, I am convinced that the worldwide ecology movement is of great importance and will provoke some of the most significant art of the next decade.

Sonfist's temperament is different from Hans Haacke's — more relaxed and less intellectual — but his mainstream of inspiration

85 Alan Sonfist. Rectangular crystal enclosure >

seems to me similar. He was born in New York in 1946, and is now a Fellow at the Center for Advanced Visual Studies, MIT. My illustration shows what is for me by far his finest piece (several variants of it have been made), which uses natural mineral crystals within a hollow glass sphere sealed at its cylindrical base. The configurations formed within it are never twice the same, but follow a self-regenerating cycle: (1) the crystals fall to the base through gravity; (2) on application of heat or light, the crystals are vaporized into a purplish gas which migrates upwards throughout the spherical space; (3) the vapour crystallizes and the crystals adhere to the inside surface of the glass.

Other pieces of Sonfist's (not all of them equally successful, and some of them frankly feeble) use invisible micro-organisms which are attracted by food and form an iridescent organic culture; or snails which eat their path into algae; or *Mucor* growing on bread. He has also used schooling fish and army ants.[20]

86 Alan Sonfist. Detail of micro-organism culture

87 Alan Sonfist. *Crystal Globe*, 1970–71 >

Unlike many other artists today, he is not afraid of using natural beauty in a straightforward way. His work is in the tradition of contemplative art.

In their different ways, both Haacke and Sonfist express our new perception of the whole environment as system. This would surely have appealed to poets like Donne and his 'metaphysical' contemporaries, with their frequent allusion to consonance between microcosm and macrocosm. Sonfist calls his pieces 'ecological systems', and the system illustrated here reminds me of one of Donne's elaborate poetic conceits where a geometer's sphere is reduced to a human eye or tear-drop, then enlarged to a sun or planet.

According to one social anthropologist, Michael Thompson (1970), we have hitherto tended to envisage our society as a vertical tube consuming at one end and excreting rubbish at the other; this image becomes inappropriate now, as we become conscious of recycling possibilities and of the relativity of rubbish. The gap between anus and mouth has been bridged. I know of no modern poetry which conveys this changed feeling for the environment in words. But visual works like Haacke's and Sonfist's can express a powerful symbolism. A seventeenth-century metaphysical poet might have seen Sonfist's piece in the illustration as an hour-glass, perhaps, turned in on itself and freed from time-keeping.

Ecology should become, and may already be becoming, part of all educated people's 'common core' of knowledge. In view of the decreasing prominence of the classics and of religious instruction in education, there are few other common cores available. It is of special relevance to art.

It has been a tradition for artists to respect and learn from the life around them, and from its unity and continuity. Ecology offers the artist an understanding of the functioning of this life. For instance, light is essential to life, and it has always fascinated artists. In recent years artists have begun to use the new light technologies, which include lasers, luminescent displays and optical fibres. But

few artists have equipped themselves with an understanding of why light *matters* for plants, animals and man. Marcello Salvadori, director of the Centre for the Studies of Science in Art, London, has done pioneering work in introducing such ecological ideas into art education.

Ecology may be extended, as I mentioned earlier in this chapter, to cover the whole 'technosphere'. But each of man's technologies – like his agricultural systems and his settlements – becomes a social institution, and it is increasingly impossible to separate ecology from the 'human sciences' of psychology, sociology and anthropology.

If the analogy I have proposed between art and symbiosis is a valid one – based on the analogy between artefact and organism, but stressing the process rather than the entity – then art criticism and art history are a kind of ecological exercise. Ecological terms such as 'culture' and 'climate' (as in 'climate of opinion') are already standard in socio-artistic history, as a way of describing the social environment in which art is generated and survives, and which in turn it is constantly transforming.

The world's nations are now trying to agree on a long-term collaborative policy for the proper use of material resources, for which purpose many world congresses are being convened. However, it is most unlikely that any such policy will be agreed on when there is so little conviction anywhere about non-material ends. Ecology studies the use of material resources, but there are few today to suggest convincingly how man should fulfil those psychological or metaphysical needs which make life more than 'birth and copulation and death'.

Christianity and other religions have proposed answers about the proper pursuit of non-material ends. Most religions, if not all, are profoundly ecological in proposing a detailed and higher-than-material ordering of man's relationships with the living world and the inanimate world. One has only to think of the Christian symbolism of the lamb, the fish, bread and wine, the Nativity in a stable; or of the poetic strength of the Anglican burial service. Religion might be described as a kind of transfigured ecology.

139

Nowadays most of us in the West tend to live by a hotchpotch of humanist and utilitarian moral beliefs. Literature, with a few exceptions, has tended recently to reflect states of human centrelessness rather than map new centres of significance for human life. How *can* we make up our minds about the optimum ecological use of material resources — when most of us have no idea what, if anything, makes life worth living at all?

Some say that science has put man in the position of a god. The actual situation is that man's quasi-divine powers are being usurped by politicians, bureaucrats, military strategists and corporation men, against whose pressures only a minority of scientists and technologists are prepared to take a stand. Science itself has developed its own momentum and structures of belief and morality, which are now being sharply challenged by what the American social critic, Theodore Roszak, has called the 'counter-culture' (1970). The larger branch of this movement is extremely hostile to science and technology, but a small and still embryonic branch is emerging in the USA, associated with such papers as *Radical Software* and *Whole Earth Catalogue*, which has been called the 'Counter-Technology'. For instance, Aquarius Project, based on Berkeley in California, is researching into the possibilities of 'automated communes' using both surplus hardware and the technical skills of drop-outs.

Ecology needs to be expanded to take account of the full needs and resources of man in nature, including the spiritual or metaphysical. We come back to the artist. Once he was the servant of a religion or the state, if often a wayward servant. Today, the artist is his own master in a sense, but he is surely as influential as ever. His potential impact on society is in the longer term than that of social and political activists, and is rarely direct or predictable.

I use the word artist — as throughout this book — to mean simply someone of superior imagination or clairvoyance which is expressed through some medium or other. In the act of coordinating his technical resources, he has to coordinate his own 'nature' — his psychological resources; and to do this can be to enact new meanings.

The artist is likely to become the 'minister' of a higher ecology of his own definition. Art has always conveyed that the physical factors in life — continuity and growth, the struggle for survival, the satisfaction of basic drives, and so on — have an element about them which is more than physical. Moreover, emotions and states of mind can only be communicated through a physical medium. The social sciences are inadequate to give a full account of the relationship between the physical and the 'cultural'. This is classically and essentially the province of art.

The Implications of Linguistics

In this chapter I shall try to suggest some different ways in which the science of linguistics can illuminate our understanding of art and culture. Language is a phenomenon whose complexity seems to defy all attempts at systematic analysis; but at the same time modern attempts to articulate the unique genius of the human species have placed language very near the centre of the human sciences, richly interconnected with such disciplines as psychology, philosophy, biology and ethnology.

In this book I have touched on the computer and on cybernetics. I have mentioned that the systematic and rigorous notation of transformations has given a new vocabulary to both ecology and linguistics. In linguistics the work of the great American grammarian Noam Chomsky has been very influential.

It is now generally accepted, even by those who have challenged Chomsky's formulations, that hierarchic structuring (see p. 144) is integral to language. In a sentence like 'Anyone who says that I am usually drunk is lying', there are dependencies between non-adjacent words which make it inadequate to think of sentences being formed or interpreted by means of a simple, linear series of behavioural responses from the beginning of the sentence to the end. This is particularly clear in the case of equivocal phrases like 'old men and women', which may be interpreted either as [(old men) and women] or as [old (men and women)]. A technique called 'constituent analysis' may be used to describe the hierarchic structure of sentences. Chomsky also proposes a notation of transformation or 'rewrite' rules to formulate how a grammar works. At a deeper and more controversial level, he has proposed a fuller

'transformational grammar' whose rules operate not just on individual elements but on structured strings of elements. These are held to govern such operations as agreement of number and gender, insertion of negatives, and interrogative inversion, and also express relations between active and passive. Chomsky and his followers maintain that only such a grammar can account for certain types of structural ambiguity.

I would refer any reader who wants to study these ideas further to John Lyons's lucid primer on Chomsky (1970). Here I merely want to suggest some connections between Chomsky's theory of grammar and some of the other subjects mentioned in this book. Chomsky has used the mathematical study of transformations not to advance the science of 'computational linguistics' but to argue that this science is ill-founded. However, he often refers to our grammatical knowledge as being like a kind of 'device' for operating on inputs, and he draws on a branch of mathematics called automata theory which underlay the development of practical computing devices thirty years ago. Its best-known exponent was A. M. Turing. There are thus theoretical links between linguistics, computers and the whole history of automata or determinate machines.

No one has yet adequately explored the full cultural significance of automata. Jack Burnham (1968 a) and Gustav Metzger (1969 a, b), writing on modern kinetic art, have both stressed its continuity with the history of automata, Metzger observing that

'Twentieth-century kinetic art developed in a self-imposed insulation from a tradition going back at least three thousand years. In part, this was a form of self-protection — kinetic art had in the past achieved works that dwarf the scale and mechanical ingenuity of most twentieth-century efforts.'

Automata were made in the Greek, Egyptian, Islamic, Chinese and Indian cultures, and in Europe during the seventeenth and eighteenth centuries they figured importantly in the development of modern philosophy, for instance in the ideas of Hobbes, Descartes, Leibniz and La Mettrie. They are the direct ancestors of twentieth-century control systems and information processing

143

FIGURE A
Constituent analysis

The structure of a sentence such as *The man hit the ball* can be expressed by means of a tree diagram:

FIGURE B
Transformation or 're-write' rules

In each of the following cases, the arrow signifies that the element on its left hand can be rewritten or replaced by the element/(s), on its right hand:

systems, and these practical tools are based historically on highly theoretical principles.

Chomsky's models of grammar bring up the whole question of the relationship between men and machines, but in a new idiom. Almost all advanced civilizations seem to have developed the aesthetic potential of their mechanical and chemical technologies, and it is a proper criticism of modern kinetic art that it is often merely exploiting the surface visual glamour of technology in an unoriginal way. The true significance of automata and machinery in our time is much more complicated and philosophical, as I have suggested in Chapter Three; and frankly I know of no artists who have yet come to terms with this question adequately.

Ecology is about relationships, transformations, structures and functions – all processes in time. ('What are called structures are slow processes of long duration', writes von Bertalanffy; 'functions are quick processes of short duration.') The exchange and flow of energy resources within an ecosystem – a bounded area selected for ecological study – may be tracked and measured exactly, given proper experimental conditions. By energy resources one means all that sustains life in its diversity.

If the importance of transformation in time has only recently been emphasized in discussion of the visual arts, it is because a traditional visual aesthetic prized the static and the timeless. But an intense apprehension of nature has always been near the heart of artistic activity; and such an apprehension must always have been sensitive to growth and decay, movement and equilibrium, flows of energy, trains of causally connected phenomena. Literature has, so far, proved an apter medium than any of the other arts for the description or evocation of ecological processes in time. The evolutionary success of man must originally have owed much to his facility for language, giving form and meaning to the flux of experience, enabling him to frame and test hypotheses about his world.

Perhaps the most difficult and controversial issue in linguistics today is the relationship between semantics and syntax. Nothing

comparable to the syntax of 'natural language' appears to be present in animal signal systems, and it may be hazarded that the development of syntax gave man a specially powerful tool for ordering his experience of environmental processes. In our every-day command of syntax we set up dynamic structural relationships comparable to the complex hierarchical orderings found in biology, as is argued in Koestler and Smythies' symposium book *Beyond Reductionism* (1969).

For laymen today to grasp ecological issues in all their complexity is like trying to parse a fractured jargon. But the next generation will approach these issues freshly, with all the human resources of articulation at their command. The educational system should try to hasten, clarify and enrich this process. The ecological pessimism so popular today may well be premature. My own generation was, broadly speaking, taught at school to classify and dissect nature. The ecological approach teaches us to construe and articulate nature. It is not fanciful to claim that ecology is the syntax of nature.

As more is learnt about the nature and scope of human language, it is understandable that attempts should be made to relate these studies, difficult and fragmented as they are, to the theory of art. The philosopher Richard Wollheim's *Art and its Objects* (1968), following up some of the implications of linguistics, is one of the most successful of such attempts, within its scrupulous and rather narrow limits. A more ambitious and considerably less cautious attempt is Jack Burnham's *The Structure of Art* (1971 *a*), which borrows from several bodies of theory, particularly the structural anthropology of Lévi-Strauss and the semiological analysis of Roland Barthes, to argue that there are certain invariant structures, mechanisms or procedures underlying the phenomenon of art; that the apparent evolutionary development of modern art, and the diversity of the avant-garde, mask a repetition of the same logical structures with different terms. Neither Wollheim's study nor Burnham's is conclusive but I am sure this trail of speculation will prove rewarding over the next few years.

Donald Davie, the poet and literary critic, has written an important book on the syntax of English poetry called *Articulate Energy*. This phrase seems to me a brilliant description of syntax, though Davie published his book in 1955 before the 'Chomsky revolution', and he does not borrow much evidence from systematic linguistics. Perhaps there is something similar in art to the syntax of language? I shall in this discussion, on distinguished authority, treat syntax and semantics as indissolubly connected to each other, rather than as two easily distinguishable components of language.[21]

Language is *not*, in my sense of the term, a 'medium' (though speech and writing are). Jonathan Miller (1971) has well criticized Marshall McLuhan for his apparent treatment of language as a technical medium:

'Language is not just an optional appendage of the human mind, but a constituent feature of its ongoing activity. Language in fact bears the same relationship to the concept of mind that legislation bears to the concept of parliament: it is a competence forever bodying itself forth in a series of concrete performances.'

If the term 'medium' is to be used in the discussion of linguistic performance, we should think rather of the techniques whereby linguistic competence is bodied forth. In writing, these techniques involve the sensory-motor control of a pen between the fingers, and the physical properties of paper and ink, which all together permit a stable cursive pattern to stream from a small tank of liquid. Devices like the typewriter simply incorporate a higher level of technology than the pen and ink. As for speech, it has been defined by one linguist as a 'noisy and purposeful interference with biologically essential processes' (the organs of speech being less specific to their function than, say, the lungs and stomach). If syntax is articulate energy, the energy articulated in language is in all cases *physical* — purposeful movement of the hand to manipulate implements or machines, purposeful expenditure of breath — physical energy which is given *meaning* by the process of syntactic articulation. To describe the transition from physical energy to meaning, some expression like 'psychic energy' suggests itself; but

terms of this kind are vague and depend on various competing theories of human psychology, none of which are adequate to explain the creative process of articulation.

The most mundane acts of language can thus be seen as the articulation or organization of physical energy and technical resources by the ongoing creative activity of the mind. My assumption in this book has been that art can be seen in similar terms. There are important differences. Whereas the technical media in which language is embodied are few and specialized, the range of technical resources available to art is theoretically unlimited. In practice, certain media such as paint have gained an ascendancy in certain cultures and are regarded as particularly appropriate to art. Also, if art has a 'syntax' it cannot be understood except in terms of what we call a 'style', a set of expectations common between the artist and his public. Style can be specific to a single artist or to a whole school of artists.

To analyse the syntax of style, we have to consider art history. It seems that the set of constraints or conventions governing expression is far more flexible in art — where the artist can define his own style, or modify that of another artist — than in language, far less a matter of *rules*. Both styles and rules exist, paradoxically, to be deviated from. When a style becomes a set of rules, we have academicism. The case of literature is a special one: here the style-dependent syntax of art appears to be superimposed on the rule-dependent syntax of language.

For an elegant approach to many of these questions of theoretical aesthetics, which are beyond the scope of this book, I refer the reader to Wollheim (1968, 1971). As a *Times Literary Supplement* reviewer has remarked ('The signs and language of art', 18 December 1970), Wollheim has taken from Chomsky the simple but vital insight that creativity and convention are locked together in language. Wollheim also considers lucidly what he calls the '*bricoleur* problem' from the striking comparison made by Lévi-Strauss of human culture to a *bricoleur* or handyman, who improvises only partly useful objects out of old junk: this is the problem of how certain media such as paint became accredited as

the vehicles of art. Wollheim makes an analogy between the way we accept these accreditations as familiar and natural, and the way we accept the sounds of our native language as familiar and natural. He regards these accreditations, and the limitations of choice or stringencies proper to them, as necessary for artistic expression. Technical stringencies thus interact in art history with the language-like stringencies of rules and styles.

The notion of 'articulate energy' applies particularly well to kineticism and the art that has followed it, since here, the traditional accredited media of painting and static sculpture have been discarded and very distinct energy resources are used: electrical power, gravity, air currents, heat and light, the stored energy of machinery. But all art involves the articulation of physical energies. Eliot wrote in *Four Quartets* of poetry as a 'raid on the inarticulate', and I would accept this as a neat characterization of art. Bad art often resembles a strident, over-assertive, syntactically weak use of language.

CHAPTER EIGHT

Science and Art as Modes of Enquiry

Having discussed briefly how language and art respectively articulate experience, we can now consider briefly the relationships between art and science. A lot has been written on this question lately.

David Bohm the theoretical physicist considers that 'all is art' because 'art' means simply making thought and language fit with perception. For him, scientific theories and metaphysical world-views are forms of art. He believes that both conventional language and conventional mathematics are inadequate because they express fragmentation rather than wholeness. In some remarkably interesting papers, especially 'An Inquiry into the Function of Language and Thought' (1971), he has proposed new forms of language and mathematics which would draw attention to flow and wholeness, and to the very process of ordering attention as an important dynamic aspect of reality. Commentators have pointed out that most of Professor Bohm's ideas have been anticipated — for instance, by Heraclitus, Leibniz, Charles Sanders Peirce, Whitehead and Eddington. But he makes no claim to originality.

C. P. Snow's view (1970) that science and art, as 'two kinds of understanding, two ways of dealing with experience', are clearly distinct in their natures, seems to me misleading. It is true that science and art are both social institutions, each with a long and distinct history. There are great differences between science and art as they have been practised. But I believe the two activities are fundamentally alike in being both modes of enquiry.

That science is a mode of enquiry will not, I imagine, be challenged. Many, however, would deny that this is a satisfactory

description of art. They would claim that the essence of art is the making or production of objects – or if not always of physical objects (which are clearly irrelevant in certain kinds of art) then of compositions or performances or publications or events.

This insistence on art as production has the strength of forcing attention on to an artist's work, which we can talk and argue about freely, as it has entered the public domain. (We cannot talk so interestingly about his feelings, motivations, etc.) Another strength of this view is that it is faithful to most traditional Western definitions of art – though the theoretical question of *what* is actually produced in art bristles with philosophical problems.

However, there have recently been attempts, admittedly rudimentary, to redefine art as a mode of enquiry much closer to science. I think this redefinition is theoretically valid, and that even traditional art fits the new definition fairly well. When we say that the career of an artist like Rembrandt or Cézanne is remarkable for its 'development', we are really calling attention to a sustained process of enquiry into reality, articulated in a specific medium.

There are pitfalls in this approach to art, as Brian Goodwin, a distinguished young developmental biologist, told the ICA in London recently.

'In this effort, there is a constant danger that the gap will be bridged by the reduction of art to the style of "objective" science, a sort of "objective" art which is dedicated to the elimination of all human bias or subjectivity in its composition. The detailed exploration of certain visual effects or the generation of purely random tonal sequences by computers can expand our range of sensitivity; but they can also become deliberate evasions of the central issue: an understanding and representation of our total being, of our experience and knowledge of ourselves and the world. This is the only possible valid goal of art; and it is also the only possible valid goal of science.'

The implication is that 'objective' art picks out certain elements in science, such as the elimination of human bias (if indeed this *is* possible in science, which is hotly debated by the philosophers of

88 Julio Le Parc. *Continual Light Cylinder*, 1962–67

science), while missing the main point about what science is concerned with.

Goodwin's seems to me a persuasive critique. The most influential group that has embraced the scientism he complains of has been the Paris-based Groupe de Recherche d'Art Visuel (GRAV), which included Julio Le Parc, François Morellet, Yvaral (Vasarely's son) and Horacio García-Rossi. Their 1961 statement 'General Propositions' is quoted in full by Burnham (1968 *a*). An associated movement was New Tendencies, based on Zagreb.

The concept of 'visual research' associated with these groups seems to have been a mixture of psycho-optics, experimental aesthetics and traditional expression. Some good work in each of these categories has been done. But the main contribution of these groups was in promoting the general idea of art as 'open research' and devaluing the art-product as a source of charisma. This was an important achievement for which we should all be grateful.[22]

If art is thought of as primarily a process of enquiry rather than a process of production, we must consider the true meaning of the term 'experiment' in art. Curiously, few critics or artists have scrutinized the relationship between the uses of this term in science and in art.

In science, a single experiment has little significance on its own. What matters is the research programme in which it is conceived and carried out. Yet when artists — other than those of the GRAV and New Tendencies persuasion — talk of 'experiments', they commonly mean 'one-off' occasions when something new is attempted without excessive concern about a favourable reception. When a film is billed as 'experimental', this can usually be interpreted as a warning that if one finds it boring or bad, one may be applying the wrong criteria. In art 'experiment' can even become a euphemism for failure.

A resolute attempt to refine the notion of experiment in art has been made by Stephen Bann in his *Experimental Painting*. Bann perceives that, in art as in science, the term 'experiment' is only meaningful in terms of a programme of work. He defines the experimental artist as one

'committed to a particular *path* of controlled activity, of which the works which he produces remain as evidence. In other words, the direction in which the artist moves is at least as important as the individual statements which record the track that he has taken. . . . The "experimental" procedures which I shall be tracing will therefore approach at their most extreme the scientific analogy of the research worker, whose experiments are valuable only in so far as they can be inserted into an evolving theoretical scheme. At the

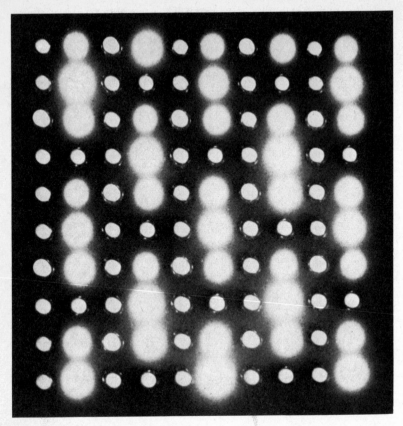

89 François Morellet. *100 Lamps*, 1964

other end of the scale, this emphasis upon the artist's "path" need imply very little more than Mondrian meant when he wrote: "True art like true life takes a single road." '

Bann does not insist that experimental art is necessarily that which adopts scientific aims or methods, though he acknowledges that the GRAV and New Tendencies artists of the 1960s did much to help make the artefact 'wither away'. He sees the career of Moholy-Nagy as one of the most significantly experimental in this century, but looking further back in art history he turns to the cloud-studies

of Constable (whose interest in science is well-documented) and to Monet's studies of haystacks and Rouen cathedral. (Turner is seen by Bann as being more 'venturesome' than 'experimental', and therein akin to the Abstract Expressionists.)

Bann's argument is powerful, and it can be pressed further. Photography can help us again. A single photograph may be 'good' by accident, as I have already argued in Chapter Two, and the great photographers are esteemed for coherent *programmes* of work. If one begins to think of certain painters and sculptors as 'experimental' (in Bann's sense), their centre of interest can shift, away from decorative set-pieces, ambitious commissions and conscious masterpieces, to their sketches and informal studies, where sometimes a deeper interest seems to have been engaged: for instance, in the case of Tiepolo to his pen and wash drawings, or in the case of Stubbs (who was an anatomist of note as well as a painter) to his *Mares and Foals* series of paintings.

Not that this emphasis on cumulative enquiry excludes the possibility of single masterpieces being created. These, after all, have usually been regarded as the product of maturity, discipline and deliberation — conceived by the artist over a period of time and slow to give up their full meaning. But Bann's idea of 'experimental art' helps divert attention away from the charisma of the object, to the organization of consciousness, and grappling with technique, that are common to all art. It also gives us the beginnings of a vocabulary for thinking of art as a mode of enquiry.

Works of art are commonly defined as 'public statements'. But if art is an enquiry, then 'public statement' now begins to sound too oratorical and assertive. *Some* works have certainly been conceived and presented as 'public statements', and should be responded to as such. But in a process of enquiry a 'statement' is not exactly what is made, any more than public statements are made in science about the nature of the universe. 'Utterance' or 'expression' seem more generally appropriate words for the activity of the artist, just as 'hypothesis', 'theory', 'conjecture' or 'speculation' seem more appropriate for the activity of the scientist. If both art and science are continuous modes of enquiry, then there are no

final answers, no revelations of absolute truths, only provisional 'models' and orderings of experience. 'Statements' in both art and science are terminated, as it were, with the question-mark.

A strong scientific hypothesis is generally held to be one that possesses explanatory power and challenges falsification (in the philosophical sense of 'disproof'). Art does not 'explain' experience (though in some special cases it may set out to); nor can art be falsified. But there is a loose analogy between the way a scientific hypothesis and an artistic utterance acquire strength. In both cases, there is an appeal for corroboration that the offered ordering of experience fits with actual experience. Moreover, though a work of art cannot be falsified, it can certainly present an aesthetic challenge. Indeed, unless it presents a strong challenge it is usually of little account.

It is often helpful if one wishes to refine on existing categories — in this instance, art and science — to examine anomalous cases. I have already discussed the work of Alan Sonfist in Chapter Six. Interestingly, one of his pieces (where crystals vaporize and condense in a container) was dismissed by an *Artforum* critic (March 1971) as a 'high-school physics project' — a scientific or technical demonstration too elementary to be taken seriously.

Looked at in this way, all of Sonfist's work would be quite meaningless. So would another piece where he uses army ants as a kind of metaphor for human society (as Nicholas Negroponte uses gerbils in *Seek*). One cannot really argue with those who refuse to respond to such work as legitimate forms of art. But one can insist that a painting by, say, Rothko is not meant to be taken as an experiment in the drying properties of paints, nor did Duchamp exhibit his famous urinal to measure the viscosity of urine. Conversely, the technical sophistication or novelty of a work of art is no guarantee of its *artistic* interest.

The work of Hans Jenny is an anomalous case which deserves to be considered in some detail. His studies of vibrations and related phenomena have been documented in a superbly illustrated book, *Cymatics* (1967), and in some remarkable lengths of film. His

work has been exhibited all over Europe and America. The name 'cymatics' is derived from the Greek word for 'waves'. Jenny is a Swiss natural scientist, and a doctor in general practice.

Jenny differs from most scientists in that he is in no sense a specialist. His studies of periodicity and vibration refer us outward to the whole range of science, revealing large areas where man's understanding of nature is suggestively incomplete.

His concept of cymatics covers both the living and the non-living world. His work originally began with a study of vibration in human muscles. An account of the importance of vibration in human physiology would include the whole phenomena of language, vision and hearing as well as modern specialized techniques like electrocardiography and electroencephalography.

From human physiology Jenny was led to study vibration and periodicity throughout animate and inanimate nature. Phenomena of periodicity and vibration occur in such diverse fields of science as histology, mineralogy, solar physics and embryology. In Chapter Four I mentioned David Bohm's idea of a universal 'holomovement'. The work of Tsai, discussed in Chapter Five, is centrally concerned with vibration.

For Jenny, cymatic phenomena are so widespread and so elusive that any partial analytic approach is inadequate. Rather than use explanatory techniques, he prefers to explore with complete open-mindedness the effects of vibrations on various substances. He insists on refraining from hypotheses until phenomena have been 'grasped' in their entirety; patiently attending on the phenomenon, as he writes, 'neither raising ourselves above it nor killing it', nor anatomizing it to a skeleton. Rather than carpenter conceptual pigeon-holes or wrap reality in neat packages, he aims to provide a new vocabulary, to 'fertilize perception, and, as it were, provide the nucleus for the formation of a perceptive organ sensitive to periodicity'.

Sometimes Jenny studies periodic phenomena occurring without an actual vibrational field: for instance, the diffusion of a dye in a liquid. But his chief technique is to use crystal oscillators to excite diaphragms or steel plates on which a substance has been

157

laid. Thus the frequency and amplitude of the vibrations can be controlled.

One of the first lessons we learn from such exercises is the highly specific behaviour of different materials, depending on heat and viscosity and other characteristics. In illustration 90, for instance, sand laid on a circular plate 16 cm in diameter has been excited at a frequency of 1060 Hz (cycles per second), and a stationary sound figure (Chladni figure) is made visible. In illustration 91, the same plate has been excited by the same frequency, but covered by a sheet of liquid instead of sand. The same pattern can be recognized, but here nothing is to be seen where the nodal lines were, whereas varied wave-fields appear in motion in the intervening areas or antinodes. It is the energizing process, and not the patterns, that Jenny invites us to experience. His book, exhibitions and films give an idea of the astonishing variety of structure and dynamics that materials exhibit under vibration.

One of his research techniques is to change the characteristics of a material *during* the process of vibration. This can be done by gradual addition of a new substance which changes the original substance's consistency, or by changing the heat of the substance. One sequence of film shows the effects of applying vibration at a constant frequency to a diaphragm where kaolin paste is being allowed to cool from a liquid to a solid state. First, Jenny's film shows the initial stages while the kaolin is still hot and liquid. Ring-shaped wave-fields are formed surrounding a central hollow, and one of the hollows has a protuberance at the centre. As the kaolin cools and becomes semi-solid, it masses together and forms round shapes.

'The ribbed pattern pulsates and circulates, the current of circulation passing up the sides of the "christmas cake" structure, over the top, down through the centre and back along the bottom to the periphery.' (See illustration 93.)

The final stage is one of complete solidity, where characteristic tree-like formations occur. In this state the kaolin can be preserved – a kind of cymatic casting. (See illustration 94.)

158

90–91 Hans Jenny. Cymatic demonstrations. >
Sand (above) and liquid on circular plate

92 Hans Jenny. Cymatic demonstration.
A soap-bubble (diameter 65 mm.) is vibrated on a diaphragm. The original sphere begins to change shape as rhythmic pulsations gather strength within its surfaces. Changes of frequency change the movement and geometry of this pulsating polyhedron

93 Hans Jenny. Cymatic demonstration, kaolin paste

Jenny has also experimented with lycopodium powder (spores of the club moss), soap-bubbles, magnetized iron-filings, water and mercury. The aesthetic interest of cymatic phenomena is not a mere matter of visual form. Artists will understand Jenny's striving towards a sensuous absorption in each cymatic phenomenon as a whole, and this absorption discloses an unexpectedness and complexity of organization such as is only rarely experienced in art: a kind of 'articulate energy'.

Is it science or art, then? Jenny describes himself as a scientist, and his work is certainly 'experimental' in the sense that it is a path of controlled activity. If we define science as simply a process of enquiry into reality, then Jenny is a scientist. But I have argued that this definition also applies to art.

Jenny certainly does not belong to the main-line scientific tradition. Not simply is he uninterested in measuring and analytical methods (mathematically speaking, cymatic phenomena can be seen as unique representations in form and movement of statistical interrelations between conflicting forces); but he offers no

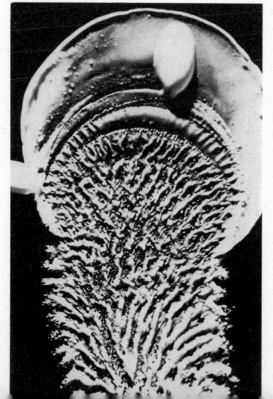

94 Hans Jenny. Cymatic demonstration, kaolin after cooling

95 (Overleaf) Hans Jenny. Cymatic demonstration, liquid. The vibration of a pure tone of sound is conveyed to the liquid through the circular diaphragm beneath it. The bulges and hollows constantly change places. When the liquid is photographed against a light (*Schlieren-photographie*), complex structures of waves and currents become visible; in this case they are all pentagonal

hypotheses, theories or predictions. But Jenny looks back to Goethe as his master. He is looking for the *Urphänomen* behind cymatics, as Goethe was looking for the *Urpflanze*, a single ideal type of plant from which all other plants could be derived intellectually, and which would express the essence of vegetative life directly to the beholder. The book *Cymatics* is dedicated to the memory of Rudolf Steiner, the mystic-philosopher who founded anthroposophy and was himself much influenced by Goethe. Significantly, Theodore Roszak — who believes that the main-line scientific tradition has been motivated by a 'prying curiosity' and 'lust for power' — looks back to Goethe's work as a possible foundation for the development of alternative modes of enquiry into reality.

Some scientists have speculated recently about ways of broadening science. Maurice Wilkins, president of the British Society for Social Responsibility in Science, writes (1971):

'There is a growing tendency for artists to regard their work as an enquiry, an open-ended activity which does not aim at producing an object but nevertheless provides a defined statement. Science may also be seen as an open-ended activity producing statements about aspects of nature rather than providing final truth. In rebuilding our culture, science may integrate with art into a broader human enquiry.'

Goethe, Rudolf Steiner and Jenny belong to a tradition which is hastily dismissed by most scientists as 'mystical'. However, it is worth reminding such sceptics that the whole concept of organic form — so central to the life sciences for the last century and a half — seems to have actually originated as a literary aesthetic before it became a guiding idea in biology. Philip C. Ritterbush (1968) argues that Goethe, Coleridge and other figures of the Romantic movement were responsible for this innovation.

What of the status of Jenny's work as art? Jenny does not claim to be an artist (though he happens also to be a painter in a naturalistic idiom). Credit is due to his photographers, especially his assistant Christian Stuten — though the use of colour filters sometimes gives

an irrelevantly glamorous, almost kitsch, effect. But with Jenny's sensitivity to dynamic structures and to the specific properties of materials, it is hard to argue that he is not an artist in a sense.

I do not recommend Jenny's approach to reality as one to be slavishly followed, or even as an exemplary synthesis of art and science (which it does not claim to be). Rather it should be praised as an example of thoroughness and conviction.

'The lot of the art critic today is not a happy one', wrote a London reviewer recently. 'Is he journalist or aesthetician, prophet or public-relations man, interpreter of tradition or adventurous iconoclast, fabricator of taste or follower of fashion?' I do not claim to have resolved this professional problem. It is not a good time to try and write a definitive book, or to make excessive claims for what has been achieved; but for me the *rapprochement* between art and science is a most exciting process. It challenges professional demarcations, trespasses on intellectual property, and demystifies brand images.

Science and art are not, however, the only aspects of our culture that need to be related more closely. As Raymond Williams has written in *The Long Revolution*:

'Politics and art, together with science, religion, family life and the other categories we speak of as absolutes, belong in a whole world of active and interacting relationships, which is our common associative life. If we begin from the whole texture, we can go on to study particular activities and their bearings on other kinds. Yet we begin, normally, from the categories themselves, and this has led again and again to a very damaging suppression of relationships.'

Appendix

Nicholas Negroponte: SEEK'S Software (1970)

SEEK's software puts its hardware into one of six modes of operation:

> Generate
> Degenerate
> Fix it
> Straighten
> Find
> Error Detect

Each mode deals in its own way with SEEK's two-inch-block real world, a world that does not match the computer's model. The mismatch occurs when the machine places the blocks, and the gerbils unpredictably move them.

Generate Mode configures the original assemblage of blocks by using a random number generator which has been programmed to have tendencies to place blocks in a manner that provides enclosures. In other words, we cannot predict where Generate Mode will place the blocks. However, we can be assured that it will build nooks, crannies, and mazes in which the gerbils may play. Generate Mode is SEEK's prime mode of operation until it has exhausted its initial 480 blocks. For most of the exhibit at the Jewish Museum in New York (except for a power failure when SEEK must start over) the machine will have completed its initial construction and be running in one of the other above modes of operation.

Degenerate Mode occurs when all the blocks have been used and SEEK is forced to take blocks from one part of the site and stack them at another. One can tell if SEEK is in fact in this mode by long pauses (between thirty and sixty seconds) of the hardware and a twinkling of the panel lights on the Interdata. The long pauses result from over one million computations which are necessary to determine the appropriateness of removing a block as a function of the density around it.

The above two modes (Generate and Degenerate) are responsible for the arrangement of blocks. They determine the form. However, they represent less than 20 per cent of the software. The remaining software handles the unexpected events, either gerbil-provoked dislocations or machine malfunctions.

Fix it Mode is probably the mode the machine is in most of the time. SEEK must make more computations in this mode than in any other. This is because a single disruption (either a block askew, a block missing

or an added block) is good evidence that other dislocations probably exist in the immediate neighbourhood. Therefore, S E E K will check adjacent locations as well as the immediate problem. Furthermore, each apparent problem must be diagnosed, as a block can be in one of three conditions: (1) it can be slightly ajar from its original position and S E E K must simply align it with the other blocks; (2) it might be an inch or so out of place (interpreted as a gerbil-desired move), and placed at the new position; (3) it might be way out of line as a result of a toppled tower or an accidentally dropped block; in this case, it is removed.

Straighten Mode is a set of operations necessary to transport a crooked block to the block straightener. The above three modes call upon Straighten Mode when their own operation is hampered by an unaligned block. Straighten Mode transports the particular block to the block straightener (a plastic box to one side) and drops it into the moulded plastic. Often, the force of the fall alone jiggles the block into alignment. If the straightener should fail to position the block, the computer turns on a vibrator. As soon as it is straight and depending upon which mode (Generate, Degenerate, or Fix It) has called upon the services of the straightener, the block is either returned to its original location or to the pile of blocks at the far end of the pen.

Find Mode is also used by other modes of operation. It can be recognized by the small increments of motion associated with its searching. This mode results from the fact that S E E K does not have an eye and must feel around for the absence and presence of blocks. Find Mode is entered because the head reports to the Interdata that a block is present but cannot be picked up because not enough of the metallic surface is exposed to the magnet. This mode determines where to go to pick it up.

Error Mode, although important philosophically, is not demonstrated too often. This mode checks for both hardware and software malfunctions. If an error should occur, the machine would halt itself, trigger a very loud siren and display on the lights of the Interdata the nature of the malfunction. If a cable breaks, a motor dies, a light bulb burns out, the head breaks, or the straightener does not work (or any of a hundred possible other symptoms occur) S E E K tells the operator. In most cases, one will not be able to see these error checks. One exception is the head test. A metal plate is attached to the block straightener. Periodically, if contact has not been made on one of the head's sensors for a certain number of times, S E E K will place its head upon the plate to check for electrical continuity among its sensing elements.

Technical information supplied by Nicholas Negroponte.

Notes

1 The ecology movement is now well established. It is further discussed in Chapter Six. For a summary of recent questionings of the objectivity of science, see Young (1971).

2 See Morphet (1970), on Hamilton's work.

3 Cybernetics was first formulated in the modern sense by Norbert Wiener (1948), although the word had been used before. The term has been given a wider definition by W. Ross Ashby (1956). Meanwhile Ludwig von Bertalanffy has defined General System Theory (see especially his book of that name, 1968) in a broad sense roughly comparable to Ashby's use of the term 'cybernetics', but taking in a number of other ideas.

4 See Sumner (1968).

5 See Whyte (1951 and 1968), pp. 74–77.

6 *Art-Language*, vol. 1, no. 1, May 1969, 'Introduction'.

7 Computer-animated films are one of the most financially promising applications of the computer in the visual arts, since the computer permits mechanization of a tedious manual process. See Knowlton (1968).

8 See also *Computers in the Creative Arts: A Guide for Teachers*, National Computing Centre, Manchester, 1970.

9 For a correspondence on this subject, and specifically the use of random number generating routines, see *Page* 3, 5, 6 and 8.

10 For a recent survey of work in cybernetics and the behavioural sciences, see Pask (1970). For a speculative essay, see Brodey and Lindgren (1968).

11 See *Scientific American*, September 1968, issue on Light; and Thompson and Parrent (1967), Kock (1969).

12 A catalogue for Margaret Benyon's retrospective exhibition was published by the Nottingham University Art Gallery, Department of Fine Art, Nottingham University (April 1971).

13 A laser is used to reconstruct such a hologram although it was made with a sound tone. See Metherell (1969) for a description of acoustical holography. The interaction of sound with solids and liquids is different from that of light. 'Sound can travel a considerable distance through dense, homogeneous matter and lose little energy, and yet it will lose a significant amount of energy when it passes through an interface. . . . Therefore sound can be singularly effective in medical diagnosis, in non-destructive testing and in seeing underwater and underground because it is mostly the dis-

continuities of internal organs, tumours, flaws, submerged objects or subterranean strata, rather than the bulk matter, that is of interest to the observer.' An acoustical hologram has the same advantage of three-dimensionality over an ordinary sound 'image' (such as is used in mineral prospecting, medicine, etc.) as an optical hologram has over a photograph.

14 For comprehensive accounts of recent art which uses interference patterning and similar effects, see Barrett (1970) and Popper (1968).

15 For instance, Pribram (1966) refers to holography in attempting to model a type of memory mechanism continually tuned by inputs to process further inputs, suggesting that 'arrival patterns in the brain constitute wave fronts which by virtue of interference effects can serve as instantaneous analogue cross correlators to produce a variety of moiré-type figures. . . . By means of some recording process analogous to that by which holograms are produced, a storage mechanism derived from such arrival patterns and interference effects can be envisioned.' Lashley (1951) has postulated that the transmission of messages within the richly connected cerebral cortex takes place by the superimposition of fluctuating patterns, resulting from current stimulation, against a substratum of persistent rhythms. Especially poetic is his illustration of the brain's nervous action as the surface of a lake (written before laser holography was developed): 'The prevailing breeze carries small ripples in its direction, the basic polarity of the system. Varying gusts set up crossing systems of waves, which do not destroy the first ripples, but modify their form, a second level in the system of space coordinates. A tossing log with its own period of sub-mersion sends out periodic bursts of ripples, a temporal rhythm. The bow wave of a speeding boat momentarily sweeps over the surface, seems to obliterate the smaller waves yet leaves them unchanged by its passing, the transient effect of a strong stimulus. Wave motion is not an adequate analogy because the medium which conveys the waves is uniform, whereas the nerve cells have their individual characteristics of transmission which at every point may alter the character of the transmitted pattern.' The phenomenon of holography has also been used to argue a congruence between Leibniz's monadology and our modern concept of the neuron.

16 Eliot writes profoundly in a critical work (1950): 'It is ultimately the function of art, in imposing a credible order upon ordinary reality, and thereby eliciting some perception of an order *in* reality, to bring us to a condition of serenity, stillness, and reconciliation.' This idea recalls the organizing function of the laser beam. It is perhaps not over-fanciful to see some premonition of laser holography in Eliot's 'Burnt Norton' (1935):

> *Sudden in a shaft of sunlight*
> *Even while the dust moves*
> *There rises the hidden laughter*
> *Of children in the foliage*
> *Quick now, here, now, always . . .*

17 The philosopher Maurice Merleau-Ponty argues convincingly (1945) against any theory of movement abstracted from our total experience of space and time.

18 See note 3 for a comment on the terms 'cybernetics' and 'general systems theory'.

19 See also *Studio International*, June and July 1971.

20 Sonfist has also taken part in ecology demonstrations, and has proposed a model ecosystem for Central Park, that would re-create as closely as possible the ecology of Manhattan before urbanization and landscaping of the park.

21 Chomsky (1965) argues that semantics and syntax are not easily distinguishable components of language, and he has in fact been criticized by other linguists for offering too tidy and schematic a picture of these phenomena. I should add that Chomsky gives no encouragement to those who try and adapt his ideas outside the science of linguistics.

22 Brook (1970) lucidly differentiates seven different senses given to the word 'object' in recent art criticism and commentary. He concludes by deprecating the flight from publicly perceptible objects (or processes), while welcoming the new emphasis on art activities as 'the locus of free exploration, invention and creative imagination'.

Bibliography

Publications listed are those referred to in the text — not always the most important or the easiest works of a given author. However, certain publications specially recommended for further reading are marked with an asterisk (*).

Ashby, W. Ross. *1956: *An Introduction to Cybernetics*, Methuen University Paperbacks, London.

Bann, Stephen. 1970: *Experimental Painting*, Studio Vista, London; Universe Books, New York.

Barrett, Cyril. 1970: *Op Art*, Studio Vista, London; The Viking Press, New York.

Beauvoir, Simone de. 1955: 'La Pensée de droite aujourd'hui', in *Privilèges*, Gallimard, Paris.

Beer, Stafford. 1960: *Cybernetics and Management*, English Universities Press, London; John Wiley, New York.

Bertalanffy, Ludwig von. 1968: *General System Theory*, George Braziller, New York.

Bohm, David. 1971: 'An Inquiry into the Function of Language and Thought' (unpublished paper).

Brett, Guy. *1968: *Kinetic Art, the Language of Movement*, Studio Vista, London; Reinhold Publishing Corporation, New York.

Brodey, Warren M., and Nilo Lindgren. 1968: 'Human Enhancement: Beyond the Machine Age', *IEEE Spectrum*, February.

Brook, Donald. 1970: 'Flight from the Object', John Power Lecture, University of Sydney.

Burnham, Jack. *1968 a: *Beyond Modern Sculpture*, George Braziller, New York; Allen Lane, London. 1968 b: 'Systems Esthetics', *Artforum*, September. 1969: 'Real Time Systems', *Artforum*, September. 1970: *Software Exhibition*, Catalogue, Jewish Museum, New York. 1971 a: *The Structure of Art*, George Braziller, New York. 1971 b: 'Hans Haacke's Canceled Show at the Guggenheim', *Artforum*, June.

Chandler, John Noel. 1969: 'Hans Haacke: the Continuity of Change', *Artscanada*, June.

Chomsky, Noam. 1965: *Aspects of the Theory of Syntax*, MIT Press, Cambridge, Mass.

Clay, Jean. 1969: 'Soto's Penetrables', *Studio International*, September. 1970: 'Aspects of Bourgeois Art: the World as it Is', *Studio International*, December.

Davie, Donald. 1955: *Articulate Energy: an Inquiry into the Syntax of English Poetry*, Routledge and Kegan Paul, London.

Douglas, Mary. 1970: 'Environments at Risk', ICA Ecology lecture, *The Times Literary Supplement*, 30 October.

Eliot, T. S. 1950: 'Poetry and Drama', in *Selected Essays*, Faber and Faber, London; Harcourt Brace Jovanovich, New York.

Forge, Andrew. 1969: 'Reflections on Aaron Scharf's *Art and Photography*', *Studio International*, May.

Franke, H. W. 1971: *Computer Graphics, Computer Art* (translated by G. Metzger), Phaidon, London.

Gabo, Naum. 1969: 'The "Kinetic Construction of 1920"', *Studio International*, September.

Greguss, P. 1970: 'Bioholography, a New Model of Information Processing' in *Progress of Cybernetics*, ed. J. Rose, Gordon and Breach, New York, vol. 1.

Hultén, K. G. Pontus. *1968: *The Machine as Seen at the End of the Mechanical Age*, catalogue, The Museum of Modern Art, New York.

Jenny, Hans. *1967: *Cymatics*, Basilius Presse, Basle (parallel English and German text).

Knowlton, Kenneth C. 1968: 'Computer-animated Movies', in Reichardt (1968).

Kock, Winston E. 1969: 'Fundamentals of Holography', *Laser Focus*, February.

Koestler, A., and J. R. Smythies. 1969: *The Alpbach Symposium 1968: Beyond Reductionism: New Perspectives in the Life Sciences*, Hutchinson, London; Collier- Macmillan International, New York.

Lashley, K. S. 1951: 'The Problem of Serial Order in Behavior', reprinted in *Perception and Action*, ed. K. H. Pribram, Penguin Books, Harmondsworth, 1969.

Lyons, John. *1970: *Chomsky*, Fontana (Modern Masters series), London; The Viking Press, New York.

McLuhan, Marshall. 1960: *McLuhan Hot and Cool*, ed. G. E. Stearn, Penguin Books, Harmondsworth. 1962: *The Gutenberg Galaxy: The Making of Typographic Man*, University of Toronto Press, Toronto; Routledge and Kegan Paul, London.

Mallary, Robert. 1969: 'Computer Sculpture: Six Levels of Cybernetics', *Artforum*, May.

Merleau-Ponty, Maurice. 1945: *La Phénoménologie de la perception*, Gallimard, Paris.

Metherell, Alexander F. 1969: 'Acoustical Holography', *Scientific American*, October.

Metzger, Gustav. *1969*a and *b*: 'Automata in History' (2 parts), *Studio International*, March and October.

Michie, Donald. 1968: 'Computer, Servant or Master', *Spectrum* no. 45 (1968), reprinted in Reichardt (1971 *b*).

Miller, Jonathan. *1971: *McLuhan*, Fontana (Modern Masters series), London; The Viking Press, New York.

Moles, Abraham. 1968: 'Théorie de l'information', 'Peut-il encore y avoir des œuvres d'art?', 'L'esthétique expérimentale dans la nouvelle société de consommation', *bit international*, no. 1, Museum of Modern Art, Zagreb. 1971: 'Art and Cybernetics in the Supermarket', in Reichardt (1971 *b*).

Morphet, Richard. 1970: *Richard Hamilton*, catalogue introduction, Tate Gallery, London.

Morrissey, Paul. 1971: Interview (with Derek Hill), *Studio International*, February.

Negroponte, Nicholas. 1970: *The Architecture Machine: Towards a More Human Environment*, MIT Press, Cambridge, Mass.

Oster, G. and Nishijima, Y. 1963: 'Moiré Patterns', *Scientific American*, May.

Pask, Gordon. 1961: *An Approach to Cybernetics*, Hutchinson, London; Harper and Row, New York. 1970: 'The Meaning of Cybernetics in the Behavioural Sciences', in *Progress of Cybernetics*, ed. J. Rose, Gordon and Breach, New York, vol. 1.

Piaget, Jean. 1971: *Structuralism*, translated by C. Maschler, Routledge and Kegan Paul, London; Basic Books, New York.

Popper, Frank. *1968: *Origins and Development of Kinetic Art*, translated by Stephen Bann, Studio Vista, London; New York Graphic Society, Greenwich, Conn.

Pribram, K. H. 1966: 'Some Dimensions of Remembering: Steps towards a Neuropsychological Model of a Memory', reprinted in *Perception and Action*, ed. K. H. Pribram, Penguin Books, Harmondsworth.

Reichardt, Jasia, ed. *1968: *Cybernetic Serendipity*, ICA exhibition catalogue, Studio International, London. 1971 *a*: *The Computer in Art*, Studio Vista, London; 1971 *b*: *Cybernetics, Art and Ideas*, Studio Vista, London.

Ritterbush, Philip C. 1968: *The Art of Organic Forms*, Smithsonian Institute, Washington.

Roszak, Theodore. 1970: *The Making of a Counter Culture*, Faber and Faber, London; Doubleday, New York.

Scharf, Aaron. 1965: *Creative Photography*, Studio Vista, London; Reinhold Publishing Corporation, New York. *1968: *Art and Photography*, Allen Lane, London.

Schöffer, Nicolas. 1970: *La Ville cybernétique*, Plon, Paris.

Schroeder, M.R. 1968: 'Images from Computers', *IEEE Spectrum*, February, and *bit international*, no. 2, Museum of Modern Art, Zagreb.

Snow, C.P. 1970: 'The Case of Leavis and the Serious Case', *The Times Literary Supplement*, 9 July.

Sumner, Lloyd. 1968: *Computer Art and Human Response*, Paul B. Victorius, Charlottesville, Virginia.

Szarkowski, John. *1966: *The Photographer's Eye* (anthology), The Museum of Modern Art, New York.

Thompson, B.J., and G.B. Parrent Jr. 1967: 'Holography', *Science Journal*, January.

Thompson, Michael. 1970: 'The Death of Rubbish', *New Society*, 28 May.

Tomkins, Calvin. *1970: 'Onward and Upward with the Arts: E.A.T.', *New Yorker*, 3 October.

Tuchman, Maurice. *1971: *A Report on the Art and Technology Program of the Los Angeles County Museum of Art*. Los Angeles County Museum of Art.

Vinklers, Bitite. 1969: 'Hans Haacke', *Art International*, September.

Waddington, C.H. 1941: *The Scientific Attitude*. Penguin Books, Harmondsworth. *1969: *Behind Appearance*, Edinburgh University Press, Edinburgh.

Walter, W. Grey. 1956: *The Living Brain*, Penguin Books, Harmondsworth.

Whyte, L.L., ed. 1951 (reprint 1968): *Aspects of Form*. Lund Humphries, London; American Elsevier, New York.

Wiener, Norbert. *1948: *Cybernetics, or Control and Communication in the Animal and the Machine*, MIT Press, Cambridge, Mass.

Wilkins, M.H.F. 1971: 'Possible Ways to Rebuild Science', in *The Social Impact of Modern Biology*, ed. Watson Fuller, Routledge and Kegan Paul, London; Doubleday, New York, 1972.

Williams, Raymond. 1961: *The Long Revolution*, Chatto and Windus, London; Columbia University Press, New York.

Wollheim, Richard. *1968: *Art and its Objects*, Harper and Row, New York; Penguin Books, Harmondsworth. 1971: 'The Art-lesson', *Studio International*, June.

Young, Robert M. 1971: 'Evolutionary Biology and Ideology: Then and Now', in *Social Implications of Modern Biology*, ed. Watson Fuller, Routledge and Kegan Paul, London; Doubleday, New York, 1972. For full annotations and references see reprint with footnotes in *Science Studies*, vol. 1, no. 2, 1971.

Page, bulletin of the Computer Arts Society, is obtainable from the CAS, c/o ICL, Brandon House, Bracknell, Berkshire, UK.

List of Illustrations

Measurements are given in inches and in centimetres, unless otherwise stated.

HARMON, LEON D.
14 *Computer Cubism?*, 1971. Bell Laboratories.

HARRISON, NEWTON (b. 1932)
83 *Fishtanks – Survival Piece*, 1971. Executed in collaboration with Jet Propulsion Laboratory, for 'Art and Technology' exhibition, Los Angeles County Museum of Art, 1971.
84 *Survival Piece 3: Portable Fish Farm*, 1971. Detail of a poster illustrating an exhibition at the Hayward Gallery, London.

IHNATOWICZ, EDWARD (b. 1926)
49 *SAM (Sound-Activated Mobile)*, 1968. By courtesy of the artist.
50 A lobster's claw, which was the inspiration for *The Senster*, in the artist's hands.
51 *The Senster*, 1971, installed at the Philips Evoluon, Eindhoven.
52 The artist working on *The Senster*.

JENNY, HANS (b. 1904)
90–91 Cymatic demonstrations. Sand and liquid vibrated on circular plates. Frequency 1060 Hz.
92 Cymatic demonstration. Soap-bubble vibrated on a diaphragm. Frequency 1060 Hz. Diameter $2\frac{1}{2}$ (6·5).
93 Cymatic demonstration. Blob of kaolin paste. Frequency 160 Hz, high amplitude. Diameter 1 (2·5).
94 Cymatic demonstration. Kaolin after cooling.
95 Cymatic demonstration. Liquid.

KAWANO, HIROSHI (b. 1925)
17 *Artificial Mondrian* (left-hand half). HITAC 5020 computer, programmed in FORTRAN with a line printer, red, yellow and blue added manually. Exhibited on Plaza Dic, Nihombashi, Tokyo.

KITAJ, R. B. (b. 1932)
3 *Mockup: Lives of the Engineers*, 1971. Environmental space, 25×20 ft ($7\cdot61 \times 6\cdot1$ m.). Executed in collaboration with Lockheed, for 'Art and Technology' exhibition, Los Angeles County Museum of Art, 1971.

KOMURA, MASAO
25–26 *Return to a Square* (a and b), 1968. Computer Technique Group, Tokyo.

LATHAM, JOHN (b. 1921)
12 Exhibit of his own X-rays, December 1971. Installation shot, 'Inno$_7$o' exhibition, Hayward Gallery, London.

LE PARC, JULIO (b. 1928)
88 *Continual Light Cylinder*, 1962–67. $118\frac{1}{2}$ (diameter) $\times 19\frac{3}{4}$ (300×50).

LIFTON, JOHN
46 Projection modulator (early prototype), 1969.

MILOJEVIĆ, PETAR (b. 1936)
39 From the *Flora* series, 1968. By courtesy of the artist.

MOHOLY-NAGY, LÁSZLO (1895–1946)
65 *Light-space Modulator*, 1930. Height $59\frac{1}{2}$ (151), base $27\frac{1}{2} \times 27\frac{1}{2}$ ($69\cdot8 \times 69\cdot8$). Busch-Reisinger Museum, Cambridge, Mass.

MORELLET, FRANÇOIS
(b. 1926)
89 *100 Lamps*, 1964.

NAKE, FRIEDER (b. 1938)
27 Computer-aided drawing,
1966. Prize-winning entry of the
annual 'Computer Art' contest
organized by *Computers and
Automation* in 1966.

NASH, KATHERINE, AND
RICHARD H. WILLIAMS
15 Logical flow-chart of the
ART 1 programme.
16 *Opens and Solids*, drawing
printed by ART 1.

NEGROPONTE, NICHOLAS
47–48 Two details of *Seek*,
1970. See Appendix. Exhibited
at 'Software' exhibition, Jewish
Museum, New York, 1970.

NICHOLSON, E. M. (b. 1904)
80 Ecological chart, 1970. De-
sign by Land Use Consultants.

NIEPCE, NICÉPHORE
(1765–1833)
9 The first photograph, 1826.
Pewter plate coated with bitu-
men of Judea, $8 \times 6\frac{1}{2}$ ($20 \cdot 5 \times
16 \cdot 5$). View from Niepce's win-
dow at Gras near Châlon-sur-
Saône. Gernsheim Collection,
Humanities Research Center,
University of Texas at Austin.

OLDENBURG, CLAES (b. 1929)
1–2 *Giant Icebag*, 1971. Vinyl,
hydraulic mechanism, wood,
height 7–16 ft ($2 \cdot 13$–$4 \cdot 88$ m.),
width 12–15 ft ($3 \cdot 66$–$4 \cdot 57$ m.).
Executed in collaboration with
Gemini, G. E. L., for 'Art and
Technology' exhibition, Los
Angeles County Museum of Art,
1971.

OXENAAR, R. D. E. (b. 1929)
18–21 Computer-aided stamp
designs, 1970. The first postage
stamps in the world realized
with computer aid. A plotter
controlled by a computer was
used. Designed for the Nether-
lands Post Office.

PIENE, OTTO (b. 1928)
78 Helium-inflated polyethylene
tubing (transparent), Washing-
ton 1970.

SCHÖFFER, NICOLAS (b. 1912)
66 *Spatiodynamics 25*, 1955.
Kinetic piece.
67 *Microtone 9*, 1963. Kinetic
piece.

SCHROEDER, M. R.
45 *Leprosy*. Microfilm plotter
and digital computer from an
original photograph. By courtesy
of Bell Laboratories.

SOTO, JÉSUS-RAPHAËL
(b. 1923)
59 *Monochrome Orange Picture*
(detail), 1970. $59 \times 78\frac{3}{4}$ ($150 \times
200$)

SONFIST, ALAN (b. 1946)
5 *Micro-organism Enclosure*,
1971. $36 \times 36 \times 3$ ($91 \cdot 5 \times 91 \cdot 5 \times
7 \cdot 2$).
85 Rectangular crystal en-
closure.
86 Detail of micro-organism
culture, 1970–71.
87 *Crystal globe*, 1970–71.

STAAKMAN, RAY (b. 1941)
60–63 Kinetic piece, 1971. Alu-
minium sheet controlled by com-
pressed air. Closed: $78\frac{3}{4} \times 7\frac{7}{8} \times
11\frac{1}{4}$ ($200 \times 20 \times 30$); open:
$157\frac{1}{2} \times 5\frac{7}{8} \times 11\frac{3}{4}$ ($400 \times 15 \times 30$).

STRAND, KERRY
24 *The Snail*, 1968. Computer graphic by Calcomp, Anaheim, California. Published by Motif Editions, London.

SUMNER, LLOYD (b. 1943)
22 *The Rotunda*, 1969. Computer design inspired by Thomas Jefferson's building at the University of Virginia. Computer Creations, Charlottesville, Va.
23 Computer Christmas card design, 1970. Computer Creations, Charlottesville, Va.

TAKIS VASSILAKIS (b. 1925)
76 *The Perpetual Moving Bicycle Wheel of Marcel Duchamp*, 1968. Drawing.
77 *Homage to Vaslav Nijinsky*, 1964. Permanent magnet and electromagnet.

TINGUELY, JEAN (b. 1925)
68 *Painting Machine or Metamatic*, 1961. Welded steel and rubber, 21¾×30×15 (55·3×76·2 ×38·1). Collection Stedelijk Museum, Amsterdam.
70–71 *Study No. 2 for an End of the World*, 1962.

TSAI WEN-YING (b. 1928)
6 Cybernetic sculpture, 1969. Vibrating rods and plates with strobe lighting. Howard Wise Gallery, New York.

72 Cybernetic sculpture, 1971. 8×3×2 ft (2·44×0·915×0·61 m.). Collection Mr and Mrs Lee Turner, Kansas.
73 Cybernetic sculpture, 1967–68. Stainless steel, cement and sound controlled motion with stroboscopic effects, height 9 ft (2·74 m.). Howard Wise Gallery, New York.
74 Cybernetic sculpture, 1967–68.
75 Cybernetic sculpture, 1970.

WARHOL, ANDY (b. 1930)
4 *3-D flowers and artificial rain*, 1971. 3-D printing technique and artificial rain. Executed in collaboration with Cowles Communications Inc. for 'Art and Technology' exhibition, Los Angeles County Museum of Art, 1971.
13 *Most Wanted Men No. 7, Salvatore V.*, 1963. Silkscreen on canvas, one of two panels, each 48×40 (122×101·5). Collection, Izzi Fiszmann, Antwerp.

WILLIAMS, RICHARD H., *see* NASH

YAMANAKA, KUNIO, *see* KOMURA

PHOTO CREDITS

Gertrude Marbach: 72, 74. André Morain: 59. Eric Pollitzer: 6, 73. Holger Schimtt: 77., J. C. Stuten: 95. John Webb: 11.

Index